KEY ART WORKS

Picasso
at the Musée Picasso

Anette Robinson
in collaboration with Isabelle Bréda
Translated by Trista Selous

EDITIONS
SCALA

All works reproduced here are by Pablo Picasso and form part of the Picasso *dation* exhibited
at the Hôtel Salé, unless otherwise stated.
In the captions, the place in which the work was made follows the picture's title.

To the reader

The underlying aim of the KEY ART WORKS series is to help develop a sense of how to look at a work of art, thinking about its form, colour and theme and comparing it to other works. Each book is arranged around a presentation of twelve pieces selected from the collections of a particular museum. These provide a starting point for the discussion of over a hundred works, which reveal the fundamental preoccupations of a specific artist or period in the history of art.

♦ This book presents twelve masterpieces by Picasso, chosen from the collections of the Musée Picasso in Paris, at the Hôtel Salé.

♦ The introduction explains the term *dation* and describes how the Hôtel Salé, a private residence in the Marais area of Paris, was transformed into the Musée Picasso, combining period architecture with modern art.

♦ The twelve selected pictures are analysed in detail, gradually revealing the extent of Picasso's work and some of its key elements.

♦ These analyses are arranged in five chapters, dealing with different aspects of Picasso's work: his favourite themes (the child, woman etc.), his original way of treating the world of objects (assemblage, collage, recycling), his work in other fields of art (theatre, literature) and the many different guises that he adopted throughout his life.

♦ Additional important information is supplied in the appendices:

 – An illustrated chronology situating Picasso in relation to the political and
 cultural life of his time.
 – Portraits and quotations reflecting Picasso's relationships with his friends.
 – A glossary of terms.

Contents

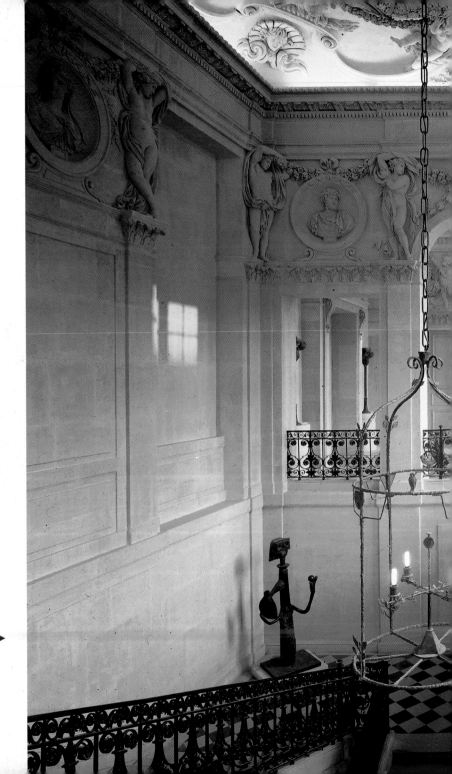

View of the Jupiter ▶
Salon on the first floor.

The main staircase
leads the visitor
straight up to the
first floor where the
museum visit begins.

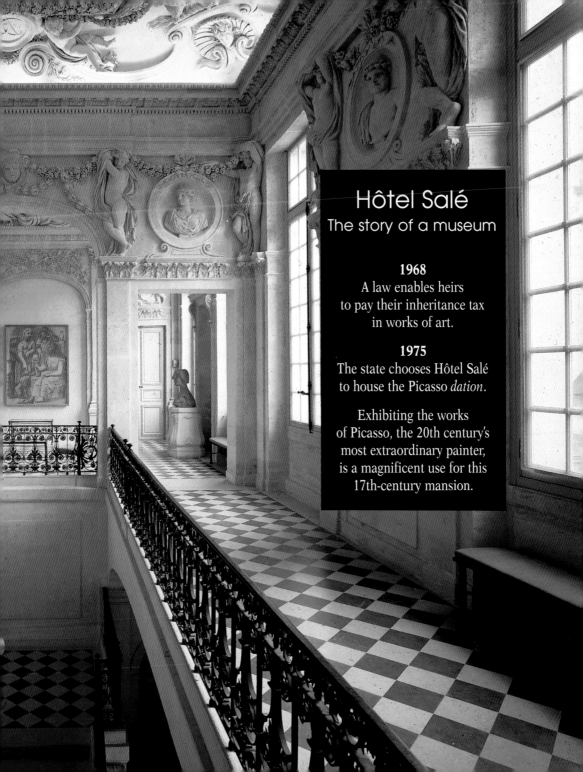

Hôtel Salé
The story of a museum

1968
A law enables heirs
to pay their inheritance tax
in works of art.

1975
The state chooses Hôtel Salé
to house the Picasso *dation*.

Exhibiting the works
of Picasso, the 20th century's
most extraordinary painter,
is a magnificent use for this
17th-century mansion.

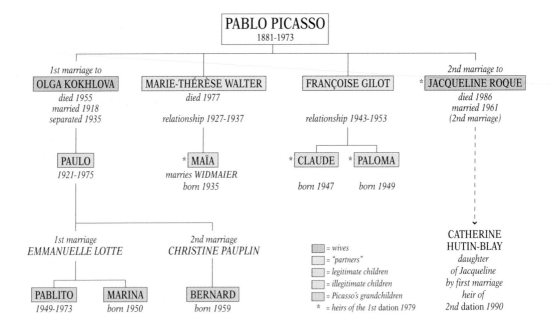

PABLO PICASSO
1881-1973

1st marriage to
OLGA KOKHLOVA
died 1955
married 1918
separated 1935

MARIE-THÉRÈSE WALTER
died 1977

relationship 1927-1937

FRANÇOISE GILOT

relationship 1943-1953

2nd marriage to
* JACQUELINE ROQUE
died 1986
married 1961
(2nd marriage)

PAULO
1921-1975

* MAÏA
marries WIDMAIER
born 1935

* CLAUDE
born 1947

* PALOMA
born 1949

CATHERINE
HUTIN-BLAY
daughter
of Jacqueline
by first marriage
heir of
2nd dation *1990*

1st marriage
EMMANUELLE LOTTE

2nd marriage
CHRISTINE PAUPLIN

= wives
= "partners"
= legitimate children
= illegitimate children
= Picasso's grandchildren
* = heirs of the 1st dation 1979

PABLITO
1949-1973

MARINA
born 1950

BERNARD
born 1959

Picasso died in Mougins on 8 April 1973, aged 92. He did not leave a will. He did, however, leave a life's work of impressive quantity and richness: 1,885 paintings, 1,228 sculptures, 7,089 drawings, 30,000 prints, 3,222 ceramics and 150 notebooks. With the addition of his personal wealth, his legacy was estimated on his death at an unbelievable 1,252,673,200 francs. "The junkyard king", as Jean Cocteau called him, was therefore one of the richest men in the world.

His death left two heirs to share the inheritance: Paulo, Picasso's son from his first marriage, and Jacqueline, who had been his wife since 1961. Although he had, in the same year, legally recognised his three other children – Marie-Thérèse's daughter Maïa and Françoise Gilot's children Claude and Paloma – they had been born out of wedlock and therefore could not inherit. All three took the state to court, finally winning in February 1974. Picasso now had five heirs. Paulo's

death the following year also made his two children heirs.

To pay the inheritance tax, all agreed to give some of Picasso's works to the state, following a law passed in 1968. This is known as a *dation* – good for the heirs because the removal of some works from the market increases the value of the rest, and also a way of enriching France's artistic heritage. The heirs agreed to allow the state to choose which works to include in the *dation*. The result was a coherent collection,

representative of Picasso's different techniques and periods. We can imagine the enormous difficulty with which the experts divided up and evaluated the works. The negotiations were endless. Maître Zécri was appointed legal administrator while Michel Guy, then Secretary of State for Culture, asked curator Dominique Bozo and a close friend of Picasso's, Jean Leymarie, to draw up the official list of works that the state could acquire. The family chose the expert Maurice Rheims to make the inventory. In 1979, six years after Picasso's death, the *dation* catalogue was completed. 203 paintings, 158 sculptures, 16 paper cut-outs, 88 ceramics, over 3,000 drawings and prints, 33 notebooks and the early works

became the property of the state. The *dation* was supplemented by the Picasso Donation. This was a collection of pictures by great artists such as Cézanne, le Douanier Rousseau, Braque and Matisse, which Picasso had amassed and had wanted to give to the state. As soon as the *dation* was announced in 1974, a crucial question arose: where would the works be housed? Such a prestigious collection needed an exceptional venue. Michel Guy suggested the Hôtel

Aubert de Fontenay, known as the "Hôtel Salé", in old Paris. One of the finest monuments in the Marais area, it was also empty. The building's owner, the City of Paris, agreed to lease the Hôtel Salé to the state. On 21 March 1975, the establishment of the Musée Picasso was agreed. The City of Paris and the state would share the costs of restoring the building, begun in 1974 by the Historical Monuments Department. This was urgent work, due to the transformations that the mansion had undergone.

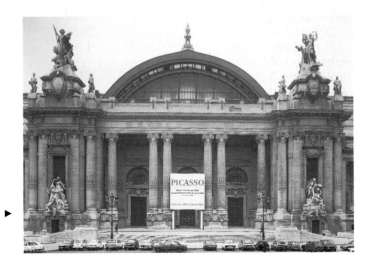

Before being finally housed in the Hôtel Salé, the *dation* was exhibited at the Grand Palais in the winter of 1979. ▶

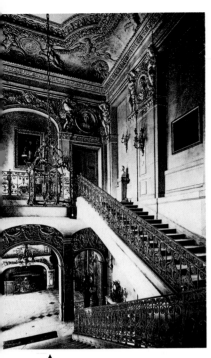

▲
Main staircase and fireplace before restoration. Photograph.

Entering from the main courtyard, the visitor encounters the square hall, which is the focal point of the ground floor. It boasts a magnificent staircase and decorative carvings *à la Versailles*.

The Hôtel Salé ('salt mansion') owes its nickname to a clever financier, Albert de Fontenay, who amassed a large fortune collecting salt tax. A magnificent two-storey residence, it was built between 1656 and 1659 by Jean Boullier, known as "de Bourges".

It stands between a courtyard (Rue de Thorigny) and a garden (Rue Vieille-du-Temple). The entrance is through the large, semi-circular courtyard, with the stable wing on the right-hand side. The interior is magnificently decorated with carvings by Gaspard and Balthazar Marsy (who later decorated the Palace of Versailles) and Martin Desjardin. The great staircase, with its two straight flights, displays unrivalled breadth and lightness for its period.

For a century and a half, the Hôtel Salé maintained its original appearance, despite its many different occupants. In 1671, it was rented by the Venetian Embassy, and in 1768 it became home to the Marquis de Juigné, who renamed it the Hôtel Juigné; by 1815 it had become a boarding house for young men and was frequented by Balzac. But in 1829, the Hôtel Salé was radically transformed when it became home to the École Centrale des Arts et Manufactures. The interior was converted to provide offices, classrooms, a library and a management suite, while the garden and courtyard accommodated lecture theatres, laboratories and refectories.

In the late 19th century the Hôtel Salé changed hands again, when the bronze-caster Vian moved

in. Then in 1943, the City of Paris leased it to house the École des Métiers d'Art, finally buying it in 1964. Four years later, the building, by then in a poor state of repair, was classified as a "historical monument". While the restoration of the building was generally welcomed, the idea of housing Picassos in a Louis XIV setting was not to everyone's taste – it was seen as a bold proposition.

However, the Hôtel Salé is perfectly suited to Picasso and his works. It recalls the large spaces in which the artist liked to live and work. Picasso loved old buildings; those that he made his home and studio include the Château de Boisgeloup, the Grands-Augustins studio, the villa "La Californie" and the Château de Vauvenargues. In 1979, the plan to transform the mansion changed again: the collection proved richer than at first thought. The Hôtel Salé's fate seems always to be bound up with tax affairs. Work began in 1983 and was completed two years later. Architect Roland Simounet faced the challenge of turning a private residence into an attractive museum, open to a large public, while preserving the 17th-century architectural structure. He turned the building's magnificent staircase to good account, using it to draw visitors upstairs.

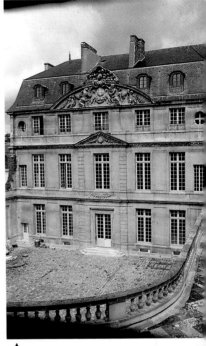

▲
Facade from the main courtyard after restoration. Photograph.

In 1974 the Historical Monuments Department decided to restore the Hôtel Salé. This great undertaking was not completed until ten years later. The main facade has a large, semi-circular pediment, with a cartouche formerly emblazoned with the Aubert coat of arms – today it shows that of the Juignés.

◄ *Facade from the main courtyard* before restoration. Photograph.

When the École Centrale des Arts et Manufactures moved into the Hôtel Salé in 1929, its overall appearance changed completely. The main courtyard, designed to set the main building back from the Rue Thorigny, was filled with a double lecture theatre, which marred the perspective.

13

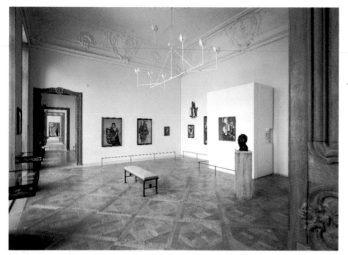

Visitors are invited to visit
the 20 galleries in
chronological order. They
start by passing through
the interconnecting rooms
of former apartments on
the first floor, on the
garden side. Most of the
ceilings and doorframes
have been preserved, but
the lights and furniture
were designed by the artist
Diego Giacometti, brother
of Alberto Giacometti.
Returning to the ground
floor, the visitor passes
through a small room with
a sloping floor and steps at
either side. Subsequently, a
gently sloping corridor
leads to the "Sculpture
Garden" a former inner
courtyard, then gradually
descends to the basement.
The visit ends on the
ground floor, where the
late Picassos can be seen.
However, visitors do not
have to follow this route
and may wander at will.

The vaulted basement with The Goat. ►
Photograph.

Roland Simounet was very
impressed by this "forest
of vaults and groins". By using
it as a gallery he avoided having
to build on the garden.
The basement is wonderfully
suited to the works from the war
and post-war periods.

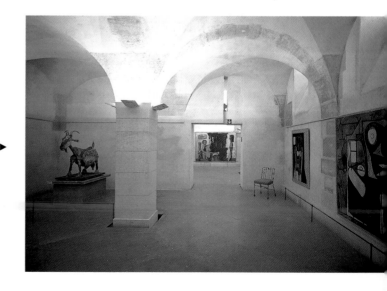

The Hôtel Salé from the garden
Today, the large garden has been
divided in two, to form a private
garden for the museum and
a public garden entered from
the Rue Vieille-du-Temple.
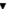

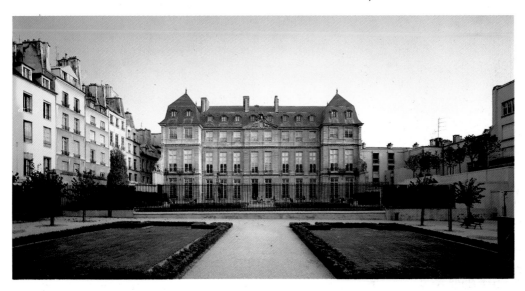

The Hôtel Salé in figures

The Hôtel Salé covers an
area of 5,458 square metres.
The rooms housing the
permanent exhibition
occupy 1,372 square metres
on three floors, including
the basement. Another
278 square metres is for
temporary exhibitions,
shown in four rooms.

The musuem currently
houses 280 paintings,
145 sculptures, 104 ceramics,
41 paper cut-outs,
2,276 prints, 1,555 drawings,
58 sketchbooks,
8 manuscripts and
73 illustrated books from
two *dations*, other forms
of acquisition, loans etc.
In addition, there are
51 paintings and drawings
from the Picasso Donation,
including works by Cézanne,
Braque, Renoir, Matisse and
Derain. In 1990, the death
of Jacqueline Picasso
enriched the collection
with a new *dation* of
Picasso's masterpieces.
Annually, the museum
receives about 350,000
visitors and stages two
temporary exhibitions.

Girl with Bare Feet,
winter 1895,
La Coruña.
Oil on canvas:
75 x 49.5 cm.

At the age of 14,
Picasso already knew

how to convey
feelings. All the
sadness of poverty
can be seen in this
little girl's face and
clothes and in the
drab colours of
the background.

▶

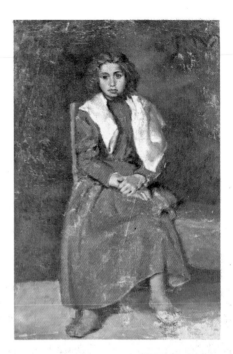

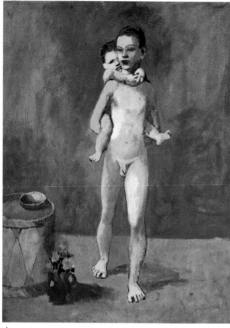

▲
The Two Brothers,
summer 1906, Gosol.
Gouache on
cardboard:
80 x 59 cm.

Picasso painted
the children naked
so that they would
communicate neither
history nor social
origins. A sense of
summer was entering
his work, as he
abandoned the
sadness of blue.

Child with Doves,
24 August 1943,
Paris.
Oil on canvas:
162 x 130 cm.

In the middle
of the war,
two doves light
up the closed world
in which the child
is imprisoned.
A message of peace
and hope.

▶

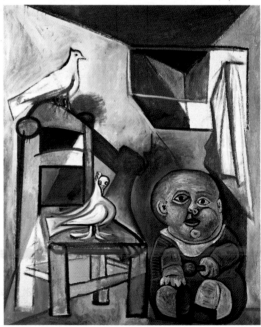

Picasso
and children

It looks like a Picasso!" Everyone has heard this comment about children's drawings or paintings. These frequently repeated words reflect the lack of understanding shown by adults when faced with what they often call "scribble". They also reveal the difficulty people have with Picasso's art.

Picasso had great respect for children's drawings. "When I was their age", he used to say, "I could draw like Raphael, but it took me my whole life to learn to draw like them".

Like children, he wanted to draw what he felt, even if the result did not "look like" what he saw. When he was young, he could never put his pictures into an exhibition of children's drawings. A glance at *Girl with Bare Feet*, which he painted at the age of 14, immediately reveals why. This painting is in a different class altogether. It is the work of a prodigy, revealing far more than mere skill; through the face of this sad little girl, Picasso has managed to convey all the melancholy of what was clearly a difficult childhood.

Throughout his life, Picasso painted images of the world of childhood. He filled his sketchbooks and canvases with them, turning them into his most wonderful sculptures.

During his "blue" period, when he was aged between 20 and 25, he painted sad, touching portraits. These were difficult years for Picasso, living half the time in Barcelona, the rest in Paris, uncomfortably, in poverty, like all artists who have not yet achieved recognition. In 1906, when he was 25, he moved to Gosol in northern Catalonia. In this austere, rugged, sun-drenched landscape he felt at home. Here, he changed his style and his vision of

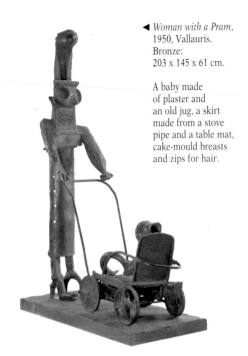

Woman with a Pram,
1950, Vallauris.
Bronze:
203 x 145 x 61 cm.

A baby made
of plaster and
an old jug, a skirt
made from a stove
pipe and a table mat,
cake-mould breasts
and zips for hair.

▲

*Child playing with
a Truck*,
1953, Vallauris.
Oil on canvas:
130 x 96.5 cm.
Jacqueline Picasso
dation.

Here, the painter
seems to have
disappeared in
order to get closer
to the child, who is
absorbed in a game.
The high angle shows
a green mass – the
lawn – against which
we can see tree
branches and flowers.

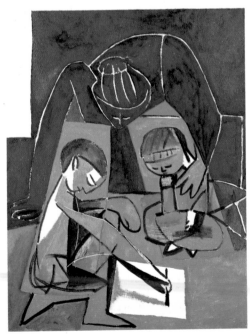

Claude drawing ▶
Françoise and Paloma,
17 May 1954,
Vallauris.
Oil on canvas:
116 x 89 cm.

All eyes are fixed
on the blank paper,
which Picasso does
not need to fill. He has
left it completely white,
like the window and
the reflected light.

children. Firstly, he freed them from the world of glacial blue, dominated by sadness, and gave up painting faces full of pathos. He started using pink-ochre backgrounds and became more interested in representing the child's body, which reminded him of the bodies of the young adolescents or ephebes often sculpted by the ancient Greeks.

When he became an adult and, later, a father (for the first time in 1921), Picasso became fascinated by the figure of the mother with her child. Many works from this period portray the gentleness and happiness of the family. Picasso's own children, Paulo, then Maïa, followed by Claude and Paloma, became his favourite models. Picasso was most interested in them as little children, up to the age of seven or eight. For him, the face and body of a child constantly and spontaneously revealed profound, authentic feeling. His fatherly love and painter's eye captured each moment of daily life. But Picasso did not act only as an observer. To understand and paint children, he had to become a child himself, seeing through a child's eyes.

Picasso was fascinated by circuses and bullfights. He loved to dress himself and his children up as clowns or bullfighters. He liked to hide behind the many kinds of masks that he made. He created toys: a little theatre for Paulo, a necklace of dried peas for Maïa. But when civil war broke out in Spain in 1936, Picasso was deeply traumatised. Once again, he changed his view of childhood. His painting was invaded by grey, from which the child arises like a promise. Childhood became a symbol of courage and hope, often linked to the dove, symbol of peace.

Childhood never departed from Picasso's world. At the age of 68, when he had just had a daughter, he played with her, down on all fours, with the same vitality and exuberance. He always looked at the world through a child's eyes. The spontaneous air of his works and the rapidity with which he made them – aspects that have often been misinterpreted – were in fact the result of a long period of work and observation.

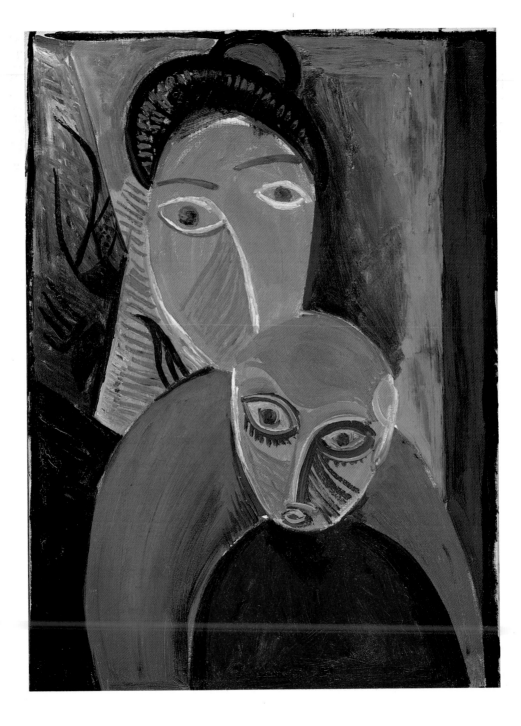

MOTHER AND CHILD
1907

The title, *Mother and Child*, suggests a celebration of love, gentleness and happiness, but nothing of the kind can be found here. Violence seems to have carried all before it, even tender feelings.

In 1907, Picasso was 26. In his studio in the Bateau-Lavoir, he had just finished *Mother and Child*. He had already painted other images on the theme, but this, his last for ten years, marks a turning-point in his work: he abandoned so-called "nice" painting and went in search of a new visual language. And yet, at first glance, the picture's composition is simple, even classical. The two figures are viewed from the front; we see their heads and shoulders in close-up, filling the entire space of the picture. The child is in the foreground, as though sitting on its mother's knee.

a few ovals and a lot of daring

What is disturbing is the childlike aspect of the drawing. The shapes have been simplified and reduced to ovals. No legs are visible: the bodies of the two figures are cut off by the painting's lower edge. Nor are there necks: the heads sit directly on the shoulders. The mother is wearing a blue hat, which hides her hair. The lower part of her face is partially hidden by the bald head of the child.

There's nothing scandalous about this. If only the figures didn't have such monstrous faces!

The Bateau-Lavoir
This was an artists' colony on the Montmartre hill in Paris, where artists lived at the beginning of the 20th century. It was here that the century's greatest revolution in painting took place: Cubist art.

◀ *Mother and Child*, summer 1907, Paris. Oil on canvas: 81 x 60 cm.

where did Picasso find his inspiration?

◄ *Mother and Child* (detail).

It was no accident that Picasso made his figures blue and red, although these were unusual colours in which to paint a mother and child. In the Middle Ages, red was the colour of Christ and blue that of the Virgin.

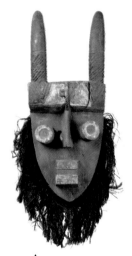

▲
Grebo mask
(Ivory Coast).
Picasso's private
collection.

In Picasso's work we see the same geometric forms and pure, simplified language.

Picasso painted exactly the opposite of what we might expect. We imagine a gentle mother and an innocent child, but we find two almost menacing faces. We expect pastel colours, yet what we see is intense red for the faces, green and blue for the background. Picasso did not choose these colours at random. In his own way, he was returning to a tradition dating from the Middle Ages in which the Virgin was dressed in a blue robe and Christ in red. Perhaps Picasso's picture is a 20th-century version of the Virgin and Child.

A picture used to be a sum of additions. In my work a picture is a sum of destructions.
Picasso.

creation through destruction

In the Middle Ages, artists did not base their work on living people. The image was always stiff, severe and majestic. It was only after the Renaissance period, in the 16th century, that the Virgin became a gentle mother and Jesus a real child. Picasso wanted to destroy this conventional image of mother and child. Just as he shattered the image of motherly love, so he broke with classical painting techniques. Until then, artists had always sought to reconstruct what they saw in terms of three dimensions. In order to convey volume and to suggest light and shadow, they would use shading. There is none of this in Picasso's work. Instead of shading, we find parallel lines known as "cross-hatching". This gives an idea of depth, but does not seek to copy it.

Why did Picasso use cross-hatching? Early in the summer of 1907 he discovered African art, with its masks and faces striped with paint.

He visited the Musée d'Art Africain et Océanien in Paris and came out overwhelmed by an art that was not content with describing reality, that did not copy it. This was a primitive, "spontaneous" art. From then on, it was for such spontaneity that Picasso strove above all else – for a new way of looking at the world. This meant he had to keep on starting from scratch.

Colours
Red, blue, yellow: primary colours.
Green (yellow + blue), orange (red + yellow), violet (blue + red): secondary colours.
Green and red, orange and blue, violet and yellow: complementary colours.

Mary Cassatt,
Mother and Child,
1897.
Pastel on paper:
55 x 66 cm.
Musée d'Orsay.

Pastel is well-suited to the theme of motherhood. It conveys a feeling of tenderness and gentleness. Along with Berthe Morisot, Mary Cassatt was part of the Impressionist group.
▼

Raphael (Raffællo Sanzio),
The Beautiful Gardener, 1506.
Oil on wood:
122 x 80 cm.
The Louvre.
▶

The picture's title is misleading. In fact, it depicts the Virgin and Child.

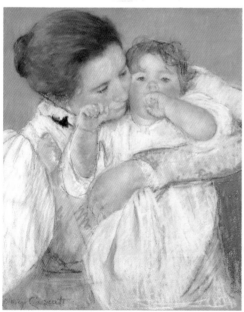

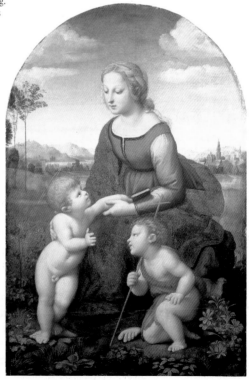

23

why did these bodies cause a scandal?

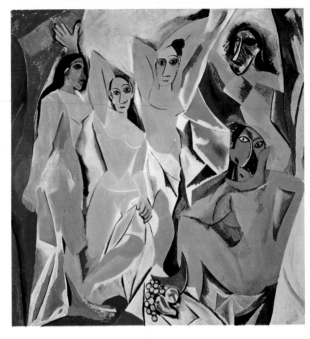

◀ *Les Demoiselles d'Avignon*, summer 1907. Oil on canvas: 2.44 x 2.34 m. Museum of Modern Art, New York.

A daring subject, but above all, a scandalous manner with which to represent it: it was Picasso's style, more than the presence of nudes, that shocked the early 20th-century public.

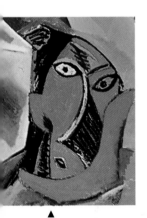

▲
Les Demoiselles d'Avignon (detail)

Simplified forms, flat colours, one continuous line from the left eye to the nose, cross-hatching to suggest shadow are all characteristic of Picasso's painting.

M*other and Child* and these *demoiselles* have many points in common. For example, their faces look like African masks, or the sculpted heads of primitive Spanish art (Iberian art). But with *Les Demoiselles d'Avignon*, Picasso was making a far greater break with traditional art. Here, space is dislocated and the bodies are distorted, as though they have been painted from several angles at once. This gives the strange impression of a broken mirror.

never seen before

This picture turned the history of painting upside-down, as the *Mona Lisa* had done four centuries earlier. For the first time, the aim was no longer to represent feminine beauty, but the reality of bodies in all their nakedness.

These *demoiselles* are prostitutes and "Avignon" is a reference to the street with that name in the red-light district of Barcelona. It was André Salmon, a poet friend of Picasso's, who gave it this title. The painting's subject was, of course, seen as shocking. But what

surprised even Picasso's friends was the new way of painting.

Only one person thought Picasso neither desperate nor mad: the collector Kahnweiler. He thought Picasso heroic. *Les Demoiselles d'Avignon* proved to him that Picasso was capable of cutting himself off completely to follow his creative instincts, whatever those around him said or thought.

heroism and provocation

Disconnected from the context of their time, these two paintings, *Mother and Child* and *Les Demoiselles d'Avignon*, still seem provocative today. Some pictures reassure and please us because they show a subject as we expect to see it. Others, like those of Picasso, give us an immediate shock and reveal that a picture has many other functions besides acting as a mirror and giving pleasure.

Daniel-Henry Kahnweiler
A German art dealer, collector, critic and publisher, Kahnweiler took an interest in the artists of the first half of the 20th century. From his gallery in the Rue Vignon in Paris, he was Picasso's main dealer.

◀ **Karel Appel**.
Children asking Questions, 1948.
Relief of painted, nailed wood.
On an oil-painted wood panel:
85 x 56 cm.
Musée National d'Art Moderne, Paris.

This Dutch painter was a member of the group of artists known as Cobra, which existed between 1948 and 1951. Here, we find the same desire to recreate spontaneous, "uncivilised" expression around the theme of childhood, based on primitive art.

▲
Amedeo Modigliani,
Head in Profile,
1911-1912. Musée National d'Art Moderne, Paris.

Like Picasso, Modigliani drew on primitive art to find a new formal language. In Modigliani's work, forms are always stretched: profiles are lengthened and eyes narrow.

25

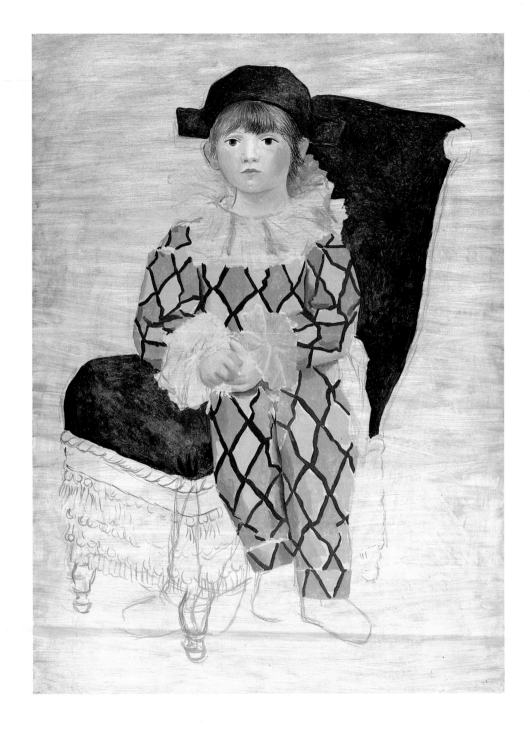

PAULO AS HARLEQUIN
1924

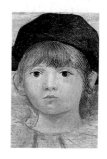

Paulo, Picasso's eldest son, painted by his father at the age of three. It is one of his most famous child portraits.

Paulo was born on 24 February 1921. His mother, Olga Kokhlova, was a dancer at the Russian Ballet, whom Picasso had married in 1918. When Picasso painted this picture, his son was only three, yet he looks as though he were five or six. This may be because he fills the entire length of the picture, which is unusual in portraits of children.

Paulo has his father's eyes: dark brown, deep and expressive. The fixed, dreamy expression that Picasso has given him in this picture, his still face and pose, radiate an impression of calm and serenity. Neither fully seated, nor actually standing, Paulo is leaning against a solid green chair. With his black hat and joined hands, he looks very well behaved for a clown dressed as Harlequin.

an unfinished picture

Some parts of the painting are minutely detailed, such as the face and hands, which look as solid as a sculpture. Others, however, are formed of flat colours and have an unfinished appearance. For example, the neutral, grey-beige background can be seen through the chair, hat and costume. Above all, the feet of both child and chair are still at sketch stage. In fact, the picture is half-way between drawing and painting.

What is a sketch?
Before painting a picture the artist makes a more-or-less elaborate plan of the composition, either on paper with pencil or charcoal, by drawing directly onto the canvas, or by painting in oils or watercolour (this is called a painted sketch).

◀ *Paulo as Harlequin*, 1924, Paris. Oil on canvas: 130 x 97 cm.

27

what makes Paulo so alive?

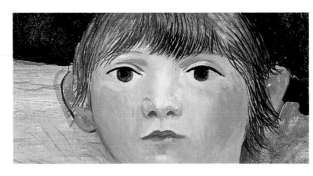

◀ *Paulo as Harlequin* (detail).

Picasso painted his son from below, to show his expression when the boy was lowering his eyes.

What is painting out?
An alteration to a composition made by the artist while working, by applying a layer of paint over it. According to classical theory, which Picasso did not follow here, painting out should be invisible. Sometimes, elements that have been painted out are discovered on an old painting when the colour pigments have become modified or when the picture is cleaned.

Can a child keep still for a painter? No. This is why Paulo has a porcelain-like face, as though Picasso had painted him from memory. Yet he is a real, living child. Proof of that is provided by the third foot at the bottom of the picture: Paulo moved and Picasso had to change his position. The hat changed places too. Picasso did not remove these mistakes by painting out, he used them to show the child's movement and life.
In the same way, he did not try to conceal his technique. For example, the background, which shows through in places, reveals that Picasso would first cover his canvas in broad, horizontal brush strokes. He would choose a soft colour – grey, pink, or, as here, grey-beige. To paint the hat and chair, Picasso uses his brush to give an uneven, speckled effect that reveals the background.
Some elements, such as the lace collar and cuffs, or the chair's feet and those of the child, are simply sketched

◀ *Paulo as Harlequin* (detail)

If Picasso had "finished" his picture, we would certainly not see this surprising third foot.

28

with a fine brush; the blue and yellow diamonds are painted without volume, in "flat colours"; the folds of cloth in the costume are suggested by a black line that zigzags across the canvas. However, the hands and face are so finely worked that they seem to stand out from the surface of the picture, and Picasso has used the old technique of "chiaroscuro" to create a shadow under the elbows and between the legs.

In leaving some sections at the sketch stage, Picasso was refusing to create an illusion, to make us believe in a three-dimensional child. It was by distancing the picture from reality and abandoning the idea of depth that he succeeded in portraying life.

Maïa with a Doll, ▶
16 January 1938,
Paris.
Oil on canvas:
73 x 60 cm.

Maïa, Picasso's second child, was three. Picasso painted her blonde hair using different shades of green. Why not? Like Paulo, Maïa moved her feet and head. The doll, on the other hand, has a pretty little face. This is as it should be: it is not alive and does not move.

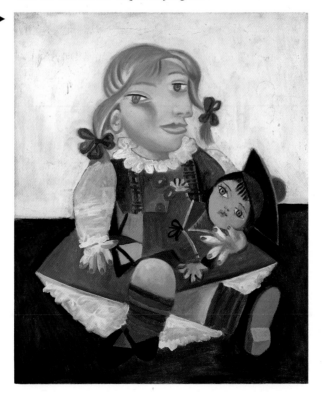

Nine times out of ten, when a painter says to you: "No, this picture's not finished, it needs a little something more, it needs finishing", nine times out of ten you can be sure that he's really going to finish it off... You know, like they finish off firing squad victims with a shot in the head.
Hélène Parmelin.

29

why did Picasso choose Harlequin?

Picasso chose to dress his son in a harlequin costume because this character from Italian comedy is part of the world of the circus, which Picasso had loved since childhood. He was fascinated by clowns, jugglers and acrobats, by their parallel universe and their life on the road.

circus fanatics

The harlequin theme appears in Picasso's work late in 1904. For nine months, he worked on *Les Saltimbanques*. At this time, as his then partner Fernande Olivier described, he would go to the Medrano circus in Paris every week, standing in the wings, chatting to the clowns, of whom Grock was to become the most famous. A few years earlier, Impressionist painters like Renoir, Degas, Toulouse-Lautrec and Seurat had gone to the Fernando Circus shows to find inspiration.

In 1904, Picasso moved to a new studio. This quickly became a meeting place for the innovative painters and poets of the day. André Salmon, Max Jacob and Guillaume Apollinaire understood Picasso. They called him the "poet in images" and helped him to discover "poetry in words". At this time, some of Picasso's paintings, sketches and engravings were like illustrations for Apollinaire's poetry.

Family of Saltimbanques, 1905. Lead pencil, Conté crayon, highlighted with brown crayon: 37.2 x 26.7 cm.

A study for *Les Saltimbanques*, held at the National Gallery of Art in Washington. ▶

◀ *The Jester*, 1905. Bronze sculpture: 40 x 35 x 23 cm.

One evening, after a visit to the Medrano Circus, Picasso decided to sculpt the portrait of his friend Max Jacob. The next day, the transformation was complete. The droll and sometimes cynical Max Jacob had become the "jester".

**Pierre-Auguste
Renoir**, *The Clown*,
1909.
Oil on canvas:
120 x 77 cm.
Musée de l'Orangerie,
Walter Guillaume
collection.

Like Picasso, but
a few years earlier,
the painter Auguste
Renoir had asked
his son Claude,
known as Coco,
to pose for him.

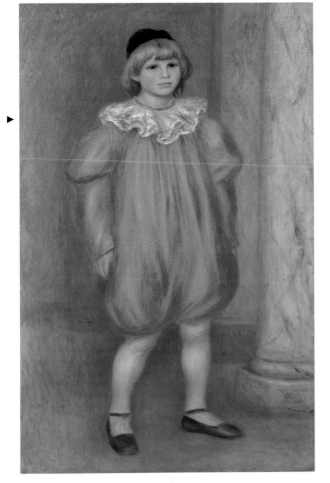

Harlequin
Like Pierrot and
Columbine, Harlequin
is a character from
Italian comedy – the
commedia dell'arte –
which was very
fashionable in
18th-century France.
Dressed up like this,
Paulo could also be
an 18th-century child.
This is the advantage
of theatrical costume,
which does not refer
to a particular place
or period.

Encouraged by Apollinaire, Picasso increasingly
identified with Harlequin, the mischievous magician
who amused the public but retained his mystery.
Paulo as Harlequin is more than simply a portrait of a
child in which the painter undoubtedly saw something
of himself (when Picasso was very small he had
depicted himself in the same costume). It is more than
a tender portrait by Picasso, the friend to all children.
This child is telling us a different story: that of the
circus people who dress up in stage costumes; the
story, perhaps, of all those who choose to wear a mask
to hide their real selves.

31

*Portrait of Olga
in a Feathered Hat*,
1920, Paris.
Lead pencil
on charcoal lines:
61 x 48.5 cm.

Elegant, wealthy
and fresh, Olga is
often shown sitting
on a chair.

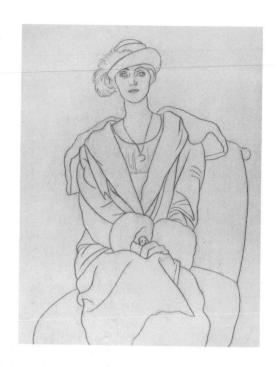

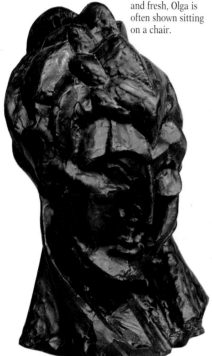

Head of a Woman
(Fernande), autumn
1909, Paris.
Bronze:
40.5 x 24 x 26 cm.

Here, all the facets
of a face miraculously
reconstitute that of
"beautiful Fernande",
like an ill-fitting
jigsaw puzzle.

*The Painter
and his Model* (Eva),
summer 1914,
Avignon.
Oil and pencil on
cloth (a kitchen cloth):
58 x 56 cm.

This scene is
deliberately
unfinished. Picasso
made many concealed
portraits of Eva, such
as a picture of a guitar
entitled *I love Eva*.

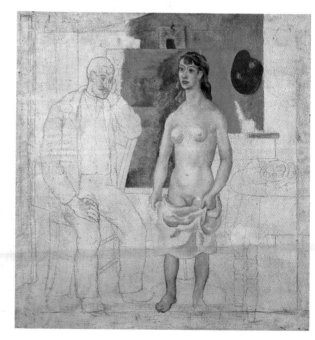

Picasso
and women

What artist does not wish to achieve glory during his or her own lifetime? Picasso had that luck. It was also a misfortune. "I should like to be illustrious and unknown", said the painter, Cézanne, in a few words that sum up the life of every artist. Creative people need the eyes of others to give life to their work. But how can artists exhibit it without exposing themselves?

I paint the way other people write their autobiographies", said Picasso. He was always fascinated by life and human beings, and he devoted the major part of his work to depicting women. He met a great many in his 92 years of life: models, muses and friends. But seven women had such an influence over his creative work that we can speak about them in terms of "periods": the Fernande, Eva, Olga, Marie-Thérèse, Dora, Françoise and Jacqueline periods. Each time a new woman came into his life, Picasso changed his style, in other words, his way of depicting things.

Sharing an artist's life is certainly no easy thing. "I must work", Picasso would constantly repeat, and this self-imposed demand also affected those around him. But, like other artists, Picasso expected the impossible of the woman who shared his life: that she should be both mother and wife, friend and muse, constantly reawakening the creative flame; that she should know how to admire while remaining objective, patient, generous, present and spiritual; that she should also know when to withdraw.

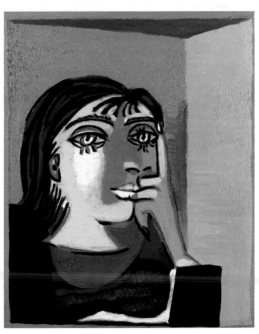

◀ *Jacqueline with
Folded Hands*, 1954,
Vallauris.
Oil on canvas:
116 x 88.5 cm.

Picasso's marriage
to Jacqueline in 1961
was headline news.
He was 80, she was 43.
Their happiness lasted
until Picasso's death
in 1973.

◀ ◀ *Portrait of Marie-
Thérèse*, 1937, Paris.
Oil and pencil
on canvas:
46 x 38 cm.

Here, Picasso
wanted to show
both Marie-Thérèse's
"Greek" profile and
her fine blue eyes.
Her blonde hair is
rendered in a range
of pastel colours.

◀ *Portrait of Dora Maar*,
1937, Paris.
Oil on canvas:
55 x 46 cm.

Dora is as dark
and sophisticated
as Marie-Thérèse is
blonde and sensual.
Brilliant colours
contrast with a
black outline.

◀ ◀ *Portrait of Françoise*,
1946.
Lead pencil, charcoal
and smudged coloured
crayon:
66 x 50.6 cm.

Lively and slim,
with her abundant
hair, Françoise is
the "flower-woman"
in Picasso's work.

In exchange, Picasso's partner would receive passion. Picasso may have been changeable in love, but he was always passionate. Each new woman was like the first. Picasso's partners did not only have the best place from which to watch the daily show of almost magical creation, they were part of it. Picasso said as much, and sometimes inscribed it in his pictures: "I love Eva".

Picasso loves intensely, but he kills what he loves". This was the conclusion of a graphological study made at the request of one of his close friends, the poet Paul Eluard. But contrary to what some people think, it was not because he did not depict them with a "photographic eye" that Picasso "mistreated" women.

Beauty in art is completely different from that found in fashion magazines. "In art", said the sculptor, Rodin, in his conversations with Paul Gsell, "only that which has character is beautiful. What is ugly in art is that which tries to be pretty or beautiful instead of being expressive, that which is vapid or precious, which is mannered without reason, all that is a parade of beauty or grace, all that lies".

For each woman, Picasso invented a new language, a new writing that enabled him to grasp and convey his model's personality. What strikes us in Picasso's work is the omnipresence of each of his women, for the duration of their relationship.

Leading an independent existence, "inhabiting" both the artist and his work, what greater homage can a woman receive from an artist?

35

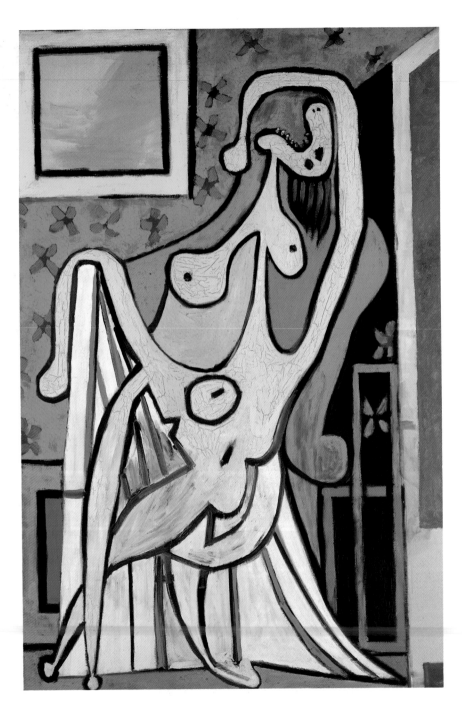

WOMAN IN AN ARMCHAIR

1929

▲
Woman in an Armchair (detail).

<u>In 1929, Picasso created this devastating image of a naked woman. It has neither beauty nor ugliness, nor even a story. All that springs from this painting is a long, piercing cry.</u>

On a chair of brilliant, almost provocative red, a naked woman is half-sitting, half-lying. Who is this person with her head thrown back and a dislocated shape that seems to be partly opened up? It is as though Picasso has done his best to destroy her by denying her body its harmony. This woman does not correspond at all to accepted ideas of the nude in painting.

why so much violence?

In 1929, nothing was going well for Picasso. The quiet family life that he had led for ten years was suffocating him, and his marriage to Olga had proved to be a failure. His painting was exploding. *Woman in an Armchair* has much in common with the *Mother and Child* painted twenty-two years earlier.

Picasso uses brilliant colours, close-up framing and, again, he takes on a subject sacred in the history of art: the nude.

But here, the painter has invented a setting for his figure. With its panelled walls and green wallpaper dotted with little flowers, this looks like the home of a family who are comfortably-off – Picasso's own?

When you paint a woman in an armchair it's old age and death, isn't it? Too bad for her. Or else it's to protect her.
Picasso to André Malraux.

◄ *Woman in an Armchair,* 1929, Paris. Oil on canvas: 195 x 130 cm.

37

why paint such an ugly nude?

Nude women have been painted since the Renaissance (16th century). Painters would celebrate beauty with pictures of women from the Bible or mythology: Eve, Aphrodite or Venus. They always idealised their models, showing them through a transparent veil, bathed in soft light.

a nude to represent beauty

The first to reject this unreality was Edouard Manet. It is hard for us to understand the scandal he provoked with his *Olympia*. He was criticised for having painted an ugly woman, with a yellow belly and dirty feet. The subject was condemned – not surprisingly when one thinks that it is a prostitute being handed flowers from her lover by a black servant! The picture was considered to be badly painted, covered with brush marks. Manet was called a "house painter" because of his raw, contrasting colours.

Henri Matisse, *Odalisque in Red Trousers*, 1921, Nice. Oil on canvas: 65 x 90 cm. Musée National d'Art Moderne, Paris.

Matisse gave his *Odalisque* (from the Arabic word *oda*, "bedroom") a similar pose to that of Picasso's *Woman in an Armchair*: arms folded behind her head. But the effect is the opposite: that which symbolises well-being and sensuality in Matisse's work is an emblem of pain in Picasso's.

▼

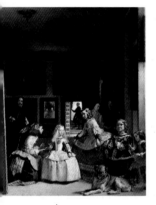

▲
Diego Velázquez, *Las Meniñas*, 1656. Oil on canvas: 316 x 276 cm. Prado Museum, Madrid.

Picasso painted 44 adaptations of this picture in five months, without the help of a reproduction. These were not copies then, but sources of inspiration that drove the painter to develop his subject.

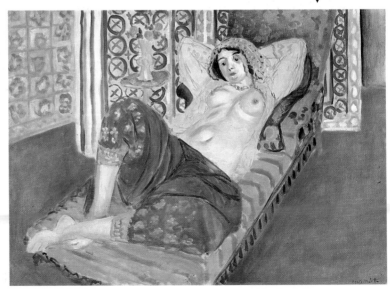

38

Picasso, in turn, refused to associate nudity with beauty. He uses loud, shocking colours. The red of the armchair complements the green of the wall, but the pink and mauve clash violently with the red. This is "pictorial chaos".

Let us enter into *Woman in an Armchair*. The atmosphere is stifling, with the wall so near, the low floor and the closed door. It is like that of *Olympia*, with its drawn curtain. And yet there may be a way out: the yellow frame at the top left. Is this a window? No, it doesn't open onto anything. A picture? Unlikely, it doesn't show anything. Then it must be a mirror. But a blind mirror, reflecting nothing. In this way, it suggests nothingness, death, and takes us back to the suffering woman. With her head thrown back and her open mouth and its pointed teeth, contorted on a chair that could be her death bed, she seems to be spitting out a pain that comes from deep inside her.

Édouard Manet,
Olympia, 1863.
Oil on canvas:
130.5 x 190 cm.
Musée d'Orsay.
▼

**The mirror
in painting**
Many painters depict
their nudes with
a mirror. Often,
it is a symbol of the
temporary nature
and vanity of reflected
beauty. It also makes
it possible to paint
"from both sides":
the artist can show
the woman from
the back, with the
reflection of her
face in the mirror.

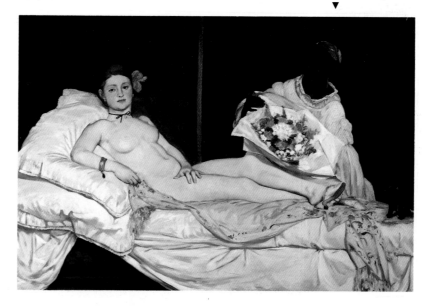

Picasso: Surrealist or loner?

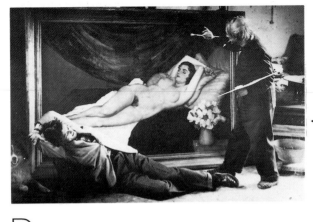

Picasso the rebel was close to the group of poets who, since 1924, had been inventing new artistic forms. André Breton was the leader of these artists, known as the Surrealists. The name comes from a letter from the poet Apollinaire, who speaks of the "surreal" and the desire to delve into the unknown in search of new things.

The Surrealists sought to convey dreams, the unconscious and hallucinations by making unexpected associations. Besides the writers, the group also included painters, such as Magritte, Salvador Dalí, de Chirico, Miró and André Masson. Their ideas were also a response to what the psychoanalyst Freud was saying in the same period: for him, human beings act primarily according to their emotions, their drives and the workings of their unconscious mind.

The Surrealist artists wanted to reach that hidden, instinctive level. The only way to do this was by breaking with all tradition.

on the Surrealist fringes

The Surrealists saw Picasso as one of their own because he represented the world not as he saw it, but as he felt it. It is true that *Woman in an Armchair* reflects this movement in the way that it shows the transposed image of a woman's body. But this painting is a long way from the dream-based images dear to the Surrealists. Picasso remained attached to the reality of his experience, in this case, a difficult married life. Picasso did not like doctrines and preferred to remain

◀ *Seated Woman*, 1929. Bronze: 42.5 x 14.23 cm.

Picasso often portrayed the same subject in both painting and sculpture. As in the painting, this woman has a dislocated body. But here, the armchair is acting as a support, without which she would fall to pieces: it is protecting her.

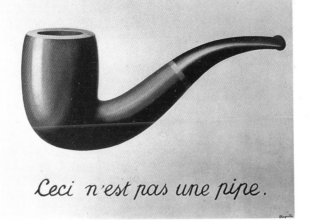

René Magritte, ▶
This Is Not a Pipe
or *The Treachery
of Images*, 1929.
Oil on canvas:
54.5 x 72.5 cm.
William N. Copley
collection, New York.

Magritte called his
paintings "visible poetic
images". They are
lessons about objects.
Through an illusionist
representation, he
reveals the paradoxical
relationship between
a real object, its name
and its image.

unclassifiable. Although he took part in the first
Surrealist exhibition in 1925 and took pride of place in
André Breton's *Le Surréalisme et la Peinture*
("Surrealism and Painting") of 1928, he still kept his
distance. "If only I were an artist!" he would repeat,
ironically, "It would be such fun..." For him, an artist
copied nature, remaining on the surface of reality.
Picasso was incapable of this.

Surrealism
*Pure automatism
through which one
tries, either verbally
or in any other way,
to express the real
functioning of thought.*
André Breton.

Some famous
Surrealists:
Louis Aragon,
Robert Desnos,
Philippe Soupault,
René Crevel,
Paul Eluard,
Jean Paulhan.

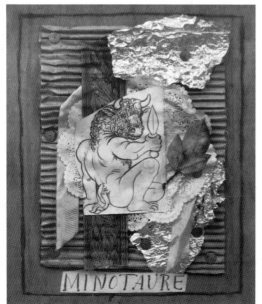

◀ Cover of the first
Surrealist journal,
The Minotaur.

The first issue of
The Minotaur came
out on 15 February
1933. Picasso made
this cover for it. It
includes, among other
things, an article on
Picasso's art, written
by André Breton
and illustrated with
photographs by
Brassaï.

*Beauty will be
convulsive
or it will not be.*
André Breton.

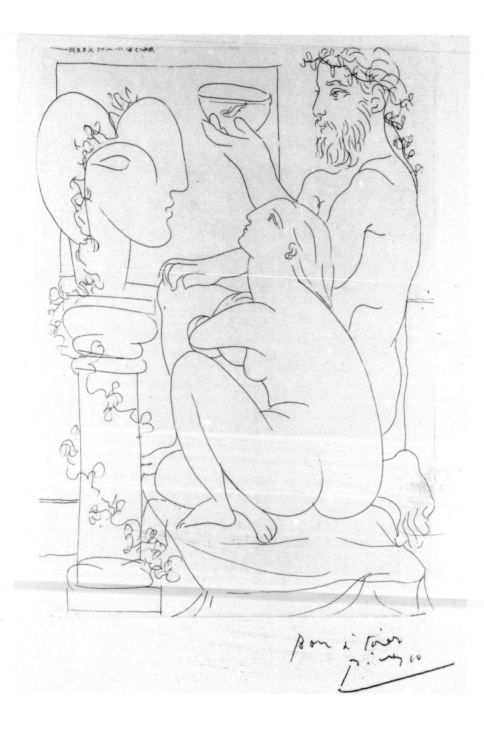

THE SCULPTOR'S STUDIO

1933

<u>Picasso took up engraving in 1899 when he was 18. In 1930 he was given a hundred plates to engrave. He devoted half of these to the same subject – the artist and his model. *The Sculptor's Studio* is one of them.</u>

Picasso was at once a painter, sculptor and engraver; at his death, 2,000 engravings were identified. When the art dealer Ambroise Vollard gave him 100 copper plates, on 46 of them Picasso tried to resolve a problem that he found very important: who am I, the artist, in relation to my model? On each of his plates, called the "Vollard Suite", he engraved a scene showing a sculptor's studio: a series of masterpieces.

return to Antiquity

This engraving shows that Picasso remained attached to classical feminine beauty. The theme is reminiscent of scenes inspired by Antiquity. A kind of bearded god, Bacchus or Dionysos, wearing a crown of leaves, is raising his cup next to a naked, half-seated young woman. In front of them a column, entwined by a plant, supports a sculpture of her head. If this is the sculptor celebrating his work by raising, not a glass of wine, but a bowl of water in which a fish is swimming, this could be because the fish represents life, in relation to an imagined, but motionless work of art.

God or father?
Yes, they all have beards... And do you know why? Each time I draw a man, involuntarily I'm thinking of my father... All the men I draw I see more or less with his features.
Picasso, *Conversations with Brassaï.*

◀ *The Sculptor's Studio,*
March 1933, Paris.
Copper-plate etching:
26 x 19 cm.
Vollard Suite,
Roger Madeleine
Lacourière donation.

43

What engraving techniques did Picasso use?

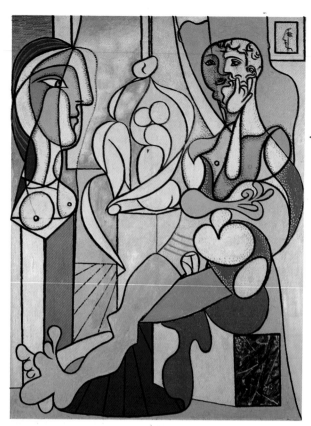

◀ *The Sculptor*, December 1931, Paris. Oil on plywood: 128 x 96 cm.

The sculptor contemplates his work. Both are seated on a stand. Yet, strangely, the sculpture seems more alive than the artist; indeed, it is the sculpted head that is looking at its creator!

▲ Ambroise Vollard (1868-1939)

Vollard was one of the first collectors to discover 19th-century talents such as the Impressionists and Post-impressionists. He greatly admired Picasso's blue and rose periods, but did not like the Cubist works.

The composition is dominated by the sculpted profile on its column. This represents the face of the naked woman sitting opposite. If we look at this profile, we see that the nose and forehead form a single line. It is reminiscent of the Greek goddesses, or the women with elongated necks that we find in Ingres' drawings. Picasso certainly much admired this neo-classical, 19th-century painter.

The bearded man, who is also naked, must be the sculptor, but there are no tools to suggest that we are in his studio. Having finished his sculpture, he seems to be looking at his work and its model for the first time. The sculpture on its base appears to fit like an image into the background frame: it has become a painting.

Picasso used a wide range of engraving techniques. Between 1905 and 1914 he engraved wood; from

Tools and the engraver's hand. Photograph taken in the Lecourière-Frelaut studio.

All the engravings in the "Vollard Suite" were printed by Roger Lacourière in the Lacourière-Frelaut studio in Montmartre.

▶

To print
Before beginning
the final print of an
engraving, test runs
are made. The artist
chooses the best of
these and accepts it
by inscribing *bon à
tirer* "to print"
followed by a
signature. A set
number of copies
are printed. After this,
the copper plate is
scratched to prevent
further printing.

1952 he engraved linoleum. But most of his
engravings are lithographs and engravings on metal,
called "line engravings". These are made either by
marking the copper plate directly with a burin and
dry-point, or indirectly, by engraving copper covered
with varnish or resin by means of acid: this
technique is known as "aquatint", "sugar aquatint",
"soft ground" or "etching". Picasso used all the
techniques in combination.

Picasso could engrave with a nail

For *The Sculptor's Studio*, Picasso chose "etching".
Because he did not take account of the fact that in
engraving it is necessary to create a "negative", the
date at the top left has come out backwards. Picasso
never listened to the advice of specialists. All his
printers were amazed at his discoveries in the field of
engraving.
Picasso, who always worked in a frenzy, would take
anything that came to hand: he would even use an
ordinary nail as a dry point. The result was always
unexpected and often extraordinary.

Etching
The copper plate
is covered on both
sides with a coating
or ground, which
comes in the shape
of a cone. Next, the
plate is held with
a clamp for heating,
which sets the ground.
The ground is then
blackened using
smoking tapers.
The engraver draws
on the ground using
a "dry point", which
exposes the copper.
The tool does not
mark the copper itself
but slides over its
surface. The copper
is then "bitten" with
nitric acid or
perchloric acid.

who is this woman?

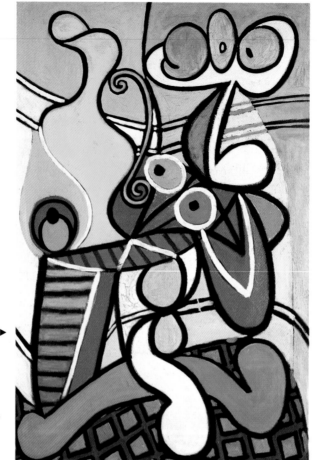

Still-life on a Table,
March 1931, Paris.
Oil on canvas:
194 x 130 cm.

Of course, this is
a still-life, but "what
a still-life!" said Picasso
to his friends. Marie-
Thérèse is everywhere:
her blonde hair is in
the pastel colour and
the shape of her body
in the curved lines.
Picasso transposes its
different parts into
fruit and plants.

In 1931, Picasso
bought the Château
de Boisgeloup. At last
he had enough space
to devote himself
to sculpture. We can
clearly see the large
sculpted head
(in plaster) that figures
on the engraving.
This new passion for
the "round bump" was
closely linked to
Picasso's new model,
Marie-Thérèse Walter.
Her sculptural beauty is
striking.

The Sculptor's Studio is reminiscent of a story written
by Balzac, *Le Chef-d'œuvre inconnu* ("The Unseen
Masterpiece"), which Picasso knew well. It takes place
at 7 Rue des Grands-Augustins in Paris in the early 17th
century. For ten years, a great painter works on his
masterpiece, *Catherine,* but keeps it hidden from prying
eyes. When he does decide to show it, it's a disaster: his
divine Catherine is nothing but a mess of intertwined
lines and colours.
Picasso may have identified with this painter. In 1931,
he illustrated the book, which was published by Vollard.
Then, in 1937, he moved to a new studio at 7 Rue des
Grands-Augustins, the address of the artist in the story.

But, during the period in which he was engraving the "Vollard Suite", Picasso's new passion and muse was Marie-Thérèse. She was then 17. Picasso was so obsessed with her that he sometimes depicts himself with the same profile, the same "big nose".

Picasso never hid such facial features; on the contrary, he emphasised them. This was not mockery. It was because he refused to bow to appearances. Some of his visual invention can be disturbing. But here, the woman's nose, her body seen at once from the side, three-quarters on, and the back, and the sculptor's stylised hands and feet are not shocking.

For Picasso, a work was never finished, the creative act was simply interrupted at a particular moment. The work no longer belonged to him; it began its own independent existence and came alive. Meanwhile, the artist could go on searching and discovering.

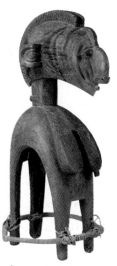

▲
Nimba sculpture
(Baga de Guinée).
Picasso's personal
collection.

This sculpture
is a fertility symbol.
But unlike our
symbols, it is not
the belly or breasts
that evoke a pregnant
woman, but the nose!

Guitar, April 1927,
Paris.
Oil on canvas:
81 x 81 cm.
Jacqueline Picasso
dation.

It may be true that
the shape of a guitar
is reminiscent of a
woman's body, but
all that remains of the
guitar are some strings
and the strap used to
hang it on the wall.
The monogram M.T.
recalls the woman
Picasso loves; the
picture becomes
a hidden love-song
sung by the guitar.

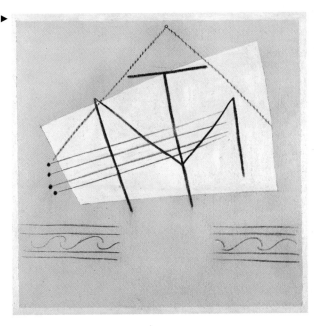

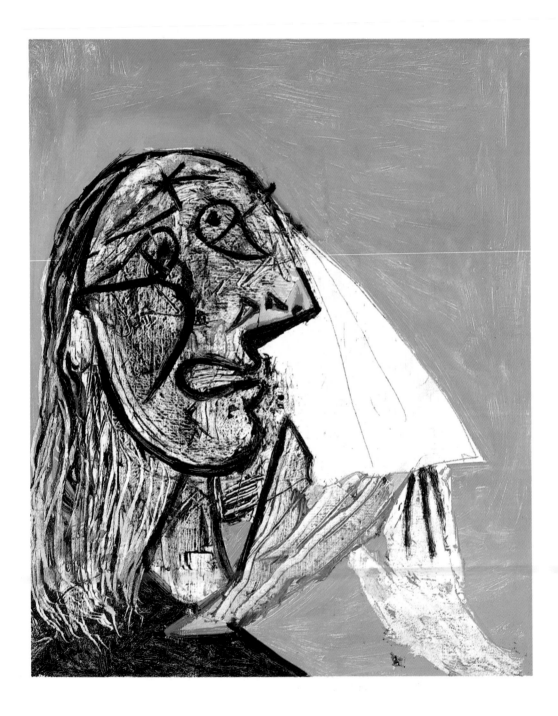

WEEPING WOMAN

1937

<u>April 1937: during the raging civil war, the town of Guernica was bombed. Picasso, distraught, began to paint a denunciation of this horrific event. He would depict all the despair of the Spanish people in *Weeping Woman*, painted six months later.</u>

Since 1936, Spain had been ravaged by civil war. On 26 April 1937, a small Basque town, Guernica, was bombed by General Franco's supporters, who were fighting the government. Picasso had never any sympathy for Fascism, and this was the reason why he lived in France instead of Spain. In early June he unveiled a masterpiece denouncing the horror of war: *Guernica*. A few months later, in October, he began to paint a number of pictures depicting women weeping. This was his way of showing the suffering of an entire people.

1937, a tragic year

This painting is as small as *Guernica* is vast. Set against a pink background, we see the dark figure of a woman, her hair undone, dressed in black. She is holding a white handkerchief to her face, which is tight with pain. This woman is crying and trying to check her sobbing. Yet Picasso has not painted a single tear. Once again, he has painted suffering itself, rather than a woman suffering.

"Spanish black"
The Spanish painters made great use of the contrast between bright colours and black. Picasso also liked to outline his brightest compositions with a black line. His work reveals a certain sense of the tragic that is an aspect of Spanish painting.

◄ *Weeping Woman*, October 1937, Paris. Oil on canvas: 55.3 x 46.3 cm.

49

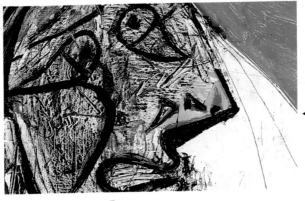

what technique to use for painting tears?

◀ *Weeping Woman* (enlarged detail).

Here and there the grain of the canvas has caught the colour, giving this criss-cross, filigree texture. This is the technique of scratching out.

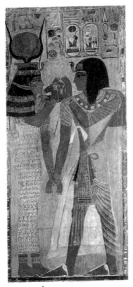

▲
Hathor and Sethi I, 13th century BC. Painted limestone. The Louvre.

Faces in profile, eyes seen from the front: thirteen centuries before the birth of Christ, the Egyptians already knew about "simultaneous vision".

Here, Picasso no longer needs a woman's body to depict suffering. He has concentrated all the sorrow in her face. To do this, he has chosen a narrow range of colours: mauve, yellow, green and black. But he has obtained a fifth colour by allowing the off-white canvas to show through.

It is clearly visible on the handkerchief and the left hand, which he has not painted. Their shapes are defined only by the line drawn round them. For the face, the opposite is true. Picasso has covered the whole surface with black and a little yellow, then rubbed the canvas against a rough surface. By scratching and scraping he has uncovered the colour of the canvas, striped with black. With a little green on the tip of the nose and the right hand, Picasso has lit up the face. The "scratching out" technique enabled him to obtain a network of criss-cross lines, a texture like that of skin. In this way, he creates the illusion of tears.

eyes like giant tears

Dipping his brush in black paint, the artist has then outlined the face and its different parts, which are depicted schematically: a black star to make a frown, a fish-like shape for the mouth, a sickle for the tight cheek. The eyes are two giant tears.

Picasso has also used schematisation in the construction of the figure's face. If we block out first the lower part of the face, and then the upper part, we can

50

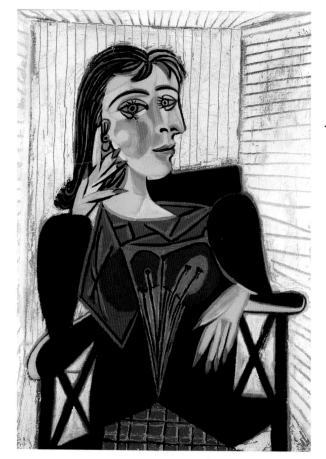

The pose, the colours,
everything in this
portrait reflects Dora's
strong personality.
With her red-painted
nails and made-up
face, she is
sophisticated, yet the
most striking things
are her eyes, one of
which is red. "For
me", said Picasso,
"Dora was always
the weeping woman".

Study of Tears,
October 1937.

Eight days after
Weeping Woman,
Picasso made this
strange study. Eyes
are pinned to a
mountain peak and
handkerchiefs cover
"pipes" for making
tears.

▼

see that the eyes and forehead are portrayed from the
front, whereas the nose and mouth are in profile.
Picasso was painting from two different angles. This
was one of his favourite techniques, known as
"simultaneous vision", which appeared in the late 1920s.
In 1935, a few years before the bombing of Guernica,
Picasso met a beautiful, dark and intelligent young
woman called Dora Maar in Paris. She was a painter
and photographer and spoke fluent Spanish. She was
someone Picasso could talk to as an equal. After this,
there were two women in the painter's life: blonde
Marie-Thérèse, his muse, "always so loving and gentle,
whose lips never spoke a word except to caress", and
dark Dora, his friend, "diabolically seductive in her
costume of tears".

**An admirer
of Paul Klee**
Many 20th-century
painters have used
"scratching out",
particularly Paul Klee.
Picasso admired Klee
enormously; like him
Klee had invented
a new, independent
visual language.
Picasso painted
Weeping Woman
in October 1937,
after visiting the
terminally-ill Klee
in Switzerland.

51

how did Picasso paint Guernica?

Picasso received his first large commission early in 1937, for the Universal Exhibition in Paris. For a few months, he painted mainly small pictures, still lifes and portraits of Dora or Marie-Thérèse. In April came the terrible news of the bombing of Guernica. Picasso saw it in the daily paper *Le Soir* on 30 April.

His Spanish heart and soul rebelled. In his new Paris studio at 7 Rue des Grands-Augustins, Picasso began to paint. On 1 May he drew the first studies. On 11 May the overall composition was finished. On 4 June, *Guernica* left the studio. The masterpiece was exhibited at the Spanish Pavilion of the Universal Exhibition, to devastating effect.

The canvas shows six figures and three animals: a horse, a bull and, between them, a bird, beating its wings. All are prisoners within the enclosed space. In

Guernica,
1937, Paris.
Oil on canvas:
351 x 782 cm.
Held from 1937
to 1981 in New York.
Since September 1981
in the Prado
in Madrid.

The lack of colour
and an insistence
on black and white
suggest a newsreel
film or the page
of a newspaper.
The horse's body in
the centre is covered
in black lines, like
printed letters.

▼

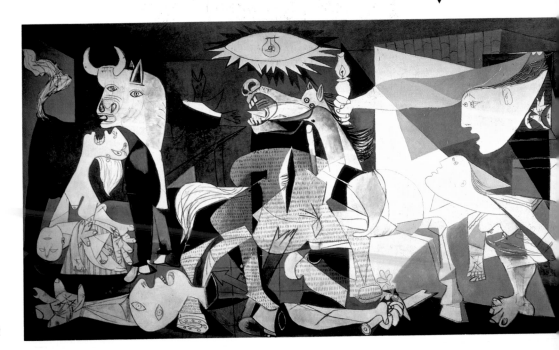

the foreground, lying on the tiled floor, a dead man still holds a broken sword. A flower seems already to be growing on the warrior's grave. To the left, a woman is holding her dead child and screaming. Her head is thrown back, a position that recalls that of the *Woman in an Armchair*.

On the other side are two women. The one on the far right is raising her arms in a gesture of despair. In her, we can recognise the *Weeping Woman:* she has the same eyes, reduced to two tears, the same frown marked by a star. The other woman has fallen to her knees with her eyes turned to the sky. It is night. Just above the horse's head, an electric bulb sheds its blinding light on the scene. But another light is being brought in from the right by a kind of genie, "the bringer of light". The arm holding this candle is very strong. Will it illuminate this carnage?

Picasso is not describing a historical event; he is denouncing its injustice and cruelty using a new visual language. His aim is to convey anguish, terror, stupor and rage. More eloquent than a series of photos, more poignant than a documentary, *Guernica* sums up all war.

After the fighting is over, the survivors' despair remains. They must learn to live with death. How can the suffering of mourning be depicted? Picasso chose to do it through weeping women. "I could do it", he said to André Malraux, "That's all. It's important because women are suffering machines. So I found the theme. Like for Guernica. Not long after Guernica".

◀ *Weeping Woman,* 1937, Paris. Plaster: 10 x 7.5 x 4 cm.

Although this weeping woman is very small, she is as majestic as her painted namesake. The size of a work does not matter. Its monumental quality comes from the force of expression.

Picasso the anti-Fascist
Picasso swore that *Guernica* would never be exhibited in Spain while Franco was alive. So it was not until 1981 that the picture returned there. A special room was built to accommodate the thousands of visitors who come to see this venerated work.

53

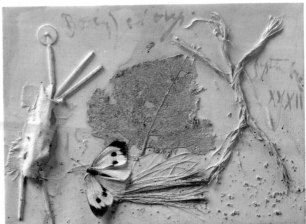

Plate with a Bunch of Grapes and a Pair of Scissors, 1948, Vallauris.
Ceramic:
31 x 37.2 x 4 cm.

With a simple plate, Picasso makes a true still-life: an oval table covered with a checked tablecloth, on which a bunch of grapes and a pair of scissors stand out in relief.

Composition with a Butterfly, 1932.
Relief painting: cloth, wood, plant material, string, drawing-pin, butterfly, oil on canvas:
16 x 22 x 2.5 cm.

For the first time, Picasso used a real butterfly: imagination meets reality.

▼

▲
Still-life in Front of a Window (Table and Guitar), 1919, Paris.
Collage coloured paper and fragment from an illustration:
26.5 x 23.5 cm.

This still-life was entirely made using scissors and glue.
Each piece of coloured paper is an element of flat colour.

Picasso and the world of objects

Few artists are both excellent sculptors and painters. Michelangelo, in the 16th century, was one of these complete artists, but we should not forget that in his time (the Renaissance), an artist had to be a kind of universal genius, capable of combining all forms of artistic expression. Picasso was also, undoubtedly, a universal artist. In his work, sculpture cannot be separated from painting, each giving inspiration to the other. In order to paint, Picasso needed to keep in contact with materials such as clay, plaster or wood – like Degas, who would model his figures in wax before painting to get a better feel for the construction of his picture. However, Picasso never sculpted with a hammer and chisel, and never carved stone. He did not feel able to create a scene from a block of marble, as Michelangelo did. What inspired Picasso was the natural form of a pebble, a tree root or a piece of wood. His powers of observation and his overflowing imagination caused him to break down the classical distinction between painting and sculpture.

Curiously, it was with the depiction of a traditional subject, still-life, that Picasso turned art upside-down. Instead of painting objects with a brush and colours, he started sticking real things onto his pictures. With his friend Braque, Picasso set out on a true adventure, cutting and sticking wallpaper, musical scores, newspaper and rags. One day he even used an old floorcloth. Then he added the idea of assemblage to that of collage: buttons, rope, matchboxes, bits of wood, nails, anything could suggest an image to him. Even the canvas support for the picture could disappear, replaced by an old shutter or a cigarette box. The picture, which until then had been a flat surface, became a relief. More than a simple reflection of reality, it became an object in itself.

Baboon with Young, 1952, Vallauris. Sculpture: Original plaster (ceramic, toy car, metal and plaster): 56 x 34 x 71 cm.

The forehead is the windscreen of a Panhard. The eyes are two balls of plaster. A Renault represents the jaw, and two vase handles stand for ears. A round jug and its handles make up the body and shoulders. The limbs are made of plaster and metal rods. The tail is a door hinge. And the baby's head? A ping pong ball.

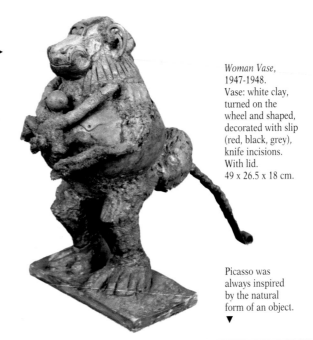

Woman Vase, 1947-1948. Vase: white clay, turned on the wheel and shaped, decorated with slip (red, black, grey), knife incisions. With lid. 49 x 26.5 x 18 cm.

Picasso was always inspired by the natural form of an object.

▼

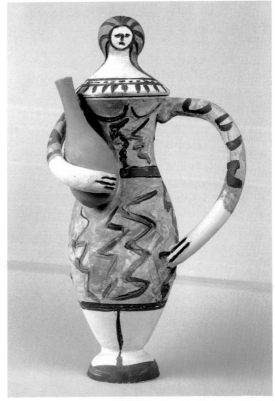

Little Girl skipping, 1950, Vallauris. Sculpture: original plaster (wicker basket, mussel shell, shoe, wood, iron, ceramic and plaster) 15.2 x 65 x 66 cm.

In 1946 in Vallauris, Picasso met the ceramicist Georges Ramié and set off on another adventure – ceramics. Kahnweiler saw this new mode of expression as "the long-desired alliance of painting and sculpture". For his first pieces, Picasso used dishes, plates, jugs and vases made by the Madoura pottery, covering them with a luminous paint called "slip", which is heat-resistant. He made his own creations from them, playing with the forms, taking advantage of faults caused during firing or an irregular surface, or working directly on the wheel. Thus, a ceramic that was no good for everyday use could be transformed by Picasso into a work of art. For example, by twisting the neck of a bottle, he turned it into a face; a vase could be transformed into a woman's body, a tile into a pigeon.

In 1948, Picasso rented a studio in Rue Fournas at Vallauris. Nearby was a dump for broken ceramics. The "junkyard king" at once set to work on this goldmine. The sculptures he made from the 50s onwards contain shards of broken pottery assembled with pieces of metal and plaster. Whether making animal or human figures, Picasso would put disparate and unexpected elements together to great effect. Most of these sculptures were then cast in bronze. But their real charm is best felt by seeing them in their original state, with the objects from which they are made.

I don't seek, I find", said Picasso. But although he used objects discovered by chance, when he put them together he made complete works of art. By altering the meaning of objects, making them undergo a metamorphosis, he also transforms our way of thinking about them, turning our idea of the reality of things upside-down. In his *Conversations avec Picasso* ("Conversations with Picasso"), Brassaï records the following words from the artist: "You have to fold objective reality carefully, the way you fold a sheet, and shut it away in a cupboard once and for all". This is his answer to all those people who always want to know what it "is".

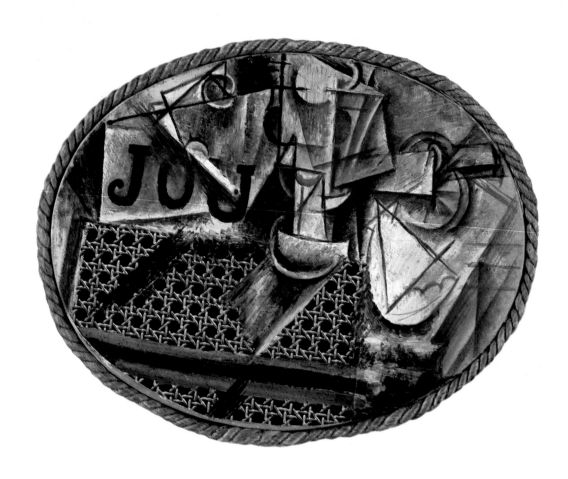

▲
Still-life
with Chair Caning,
spring 1912, Paris.
Oil and oilcloth
on an oval canvas
surrounded by rope:
27 x 35 cm.

STILL-LIFE WITH CHAIR CANING

1912

This small canvas painted in May 1912 marks a decisive turning point in the history of art. For the first time, a painter had applied material other than paint to the canvas – in this case a small piece of oilcloth. Picasso had proved that a picture could be made using means other than just brush and colour.

Picasso's two most famous pictures are *Les Demoiselles d'Avignon* and *Guernica*. They are spectacular both in size and subject matter and have attracted millions of visitors. Yet in May 1912, Picasso made a small picture, far less well-known and not at all spectacular, which had a profound effect on 20th-century art. This was *Still-Life with Chair Caning*. It's subject matter is ordinary, but the way it is depicted is very surprising.

a preposterous idea

At first, the oval form recalls some older still-lifes, but the picture frame, made of thick ship's rope, is quite extraordinary. The forms are muddled and fragmented, and colour seems to have been sacrificed. Only two elements appear clearly: three letters written in black – J O U – and the cane seating of a chair. Is this really painted? In fact it is a piece of real tablecloth. Sticking bits of cloth on a painting? What an idea!

"Mental illusion"
This is how Picasso termed his way of "naming an object without representing it". Here, we think we see a chair, whereas it is in fact oilcloth.

59

what do these fragments of images mean?

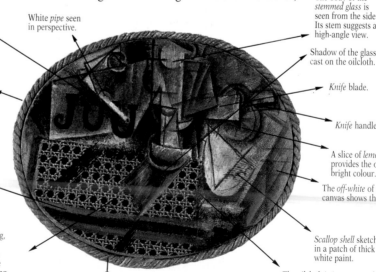

Still-life with Chair Caning (detail)

To integrate the oilcloth collage, Picasso partially painted it. The small horizontal brush strokes make a transition between the pasted surface and the canvas, while broader strokes on the cane seating help to bring it into the overall composition. The introduction of letters was also new.

Things must be named, said Picasso. So he stuck a piece of imitation cane chair seat to his picture instead of painting it. Rather than representing a whole object, he showed only part of it. In the same way, with the three letters J, O and U, he evokes *jouer* (to play) or *journal* (newspaper). Three letters resembling typeface and a palette dominated by black and white (apart from the bright yellow of the lemon) generate the idea of a newspaper. All the elements are seen from different angles: the chair from above, the pipe in perspective, the body of the glass from the side, but its stem from above. The chair's seating is seen through the table. Moreover,

JOU = jouer (to play) or *journal* (newspaper). The letters are painted in black without a stencil.

White *pipe* seen in perspective.

The picture is surrounded by *ship's rope*, suggesting the table's edge or the trimming of a tablecloth.

A stripe painted in *black, ochre and sienna*. The oilcloth collage above it suggests the chair back.

A *piece of oilcloth*, with a design like cane seating, has been cut and stuck on to the canvas. In this way Picasso "names" the chair without representing it. This is what he calls a *mental illusion*.

The body of the *stemmed glass* is seen from the side. Its stem suggests a high-angle view.

Shadow of the glass cast on the oilcloth.

Knife blade.

Knife handle.

A slice of *lemon* provides the only bright colour.

The *off-white* of the canvas shows through.

Scallop shell sketched in a patch of thick white paint.

The oilcloth is incorporated into the picture using short, sharp brush strokes.

The *oval shape* suggests either a round table seen in perspective, or an oval table seen from above.

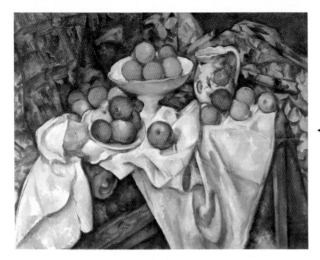

◀ **Paul Cézanne**,
Apples and Oranges,
1895-1900.
Oil on canvas:
74 x 93 cm.
Musée d'Orsay, Paris.

Cézanne uses pure
forms – cylinders,
spheres and cones –
to reconstruct an ideal
space. The tablecloth
under the crockery
and fruit links a table
and an armchair.
Each part is taken
from a different angle:
this was the first time
an artist had shifted
his point of view while
painting a picture.

Picasso has played with perspective by painting the shadows cast by the objects, and isn't that black line cutting across the bottom of the picture the chair back seen from above? The table is the picture's surface, the rope may be the table's surround, or the tablecloth trim. Why paint these different views of the objects? Since 1907 Picasso had been trying to represent things in three dimensions, without using traditional techniques. By giving a number of different viewing angles, all focused on the same image, he was trying to recreate an effect of volume and movement. This effect had been obtained for over 600 years through the use of perspective and shading.

Georges Braque,
*The Guitar,
Statue of Fear*,
November 1913.
Pasted paper,
charcoal and gouache
on paper:
73 x 100 cm.

While Picasso was
the first to integrate
a foreign element
into a canvas, Braque
was the first to make
a picture featuring
paper of different
designs, cut and stuck,
in 1912. He used
a mixture of drawing
and glued paper:
a concert programme,
wallpaper imitating
wood, and black paper.
The guitar in the centre
was cut out of a
charcoal drawing.
The letters were
stencilled. The picture
is rectangular, but it
also fits into an oval,
outlined in gouache. ▶

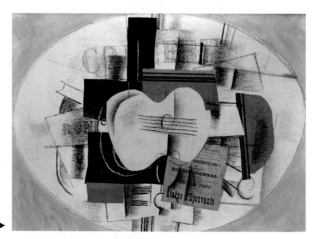

how did Cubism start?

In 1907, the poet Apollinaire introduced Picasso to a young painter, Georges Braque. Together, they were to give birth to a new school: Cubism.

At first, Cubism was influenced by Paul Cézanne, whom the young artists discovered at a retrospective exhibition in 1907. Even the German poet Rainer Maria Rilke said that his painting pushed him to change his life. The young painters understood then that they were not the first to reject perspective and shading as the only possible way to convey space and volume. In Cézanne's work, particularly in his last still-lifes, they found a concrete solution to a visual problem: painting an object from several different angles.

everything shatters in 1910

From 1910 on, they broke completely with classical painting. Representing things in the way the eye sees them became out of the question: they were to be recomposed mentally. Forms in the pictures shatter

Still-life, Jug and Skeleton, February 1945.
Oil on canvas: 74 x 92 cm.

During the Second World War, Picasso painted a number of still-lifes, all in greys. The angular forms are reminiscent of Cubism. Here, life has been stilled to the point of extinction: the candle will never wake this skeleton.

▼

Still-life with Jug and Apples, 1919.
Oil on canvas: 65 x 43.5 cm.

In 1917 Picasso seemed to abandon Cubism. He once more conveyed volume through shading, in the classical way. All the forms are round and full, expressing calm and serenity.

Henri Matisse,
Basket of Oranges, 1912.
Oil on canvas:
94 x 83 cm.

This painting is part
of Picasso's personal
collection. It was through
dialogue between colours
that Matisse solved his
problem of form, while
Picasso, in his full-blown
Cubist period, seemed
to have renounced it.

Still-life
This is the name
given to pictures
of the world of objects
– things that suggest
life, but do not move.
This genre of painting
arose in Flanders
in the 17th century.
It was known as
"resting nature"
or "dead, motionless
things". In French,
still-life is called
nature morte, or "dead
nature", but perhaps
the most appropriate
term is the German
stilleben, meaning
"silent life". Still-life
is one of the least
noble genres in
painting. It often uses
symbols to illustrate
the fragility and
ephemeral beauty
of life.

Why "Cubism"?
"Cubism" owes its
name to a jibe by the
art critic Louis
Vauxelles. On seeing
a landscape by Braque
he spoke of "little
cubes". According
to Braque, "Cubism
is an art that deals
primarily with forms".

like a broken mirror. Colour disappears to make way
for form, which is dissected and analysed. This is
called "analytical Cubism". Pictures by Picasso and
Braque became so abstract they were almost
impossible to interpret. From 1912, they tried to make
the objects easier to identify by introducing letters and
numbers, or imitating materials like marble or wood.

it takes more than glue
to make a collage

In autumn 1912 Picasso made his first "collage"
(gluing) and Braque his first *papier collé* (glued paper).
They also brought colour back at this time, with paint
or by gluing coloured paper. Picasso realised that he
could represent an object without observing it, by
giving its essential elements, making a synthesis of it;
at this time Cubism became "synthetic".

63

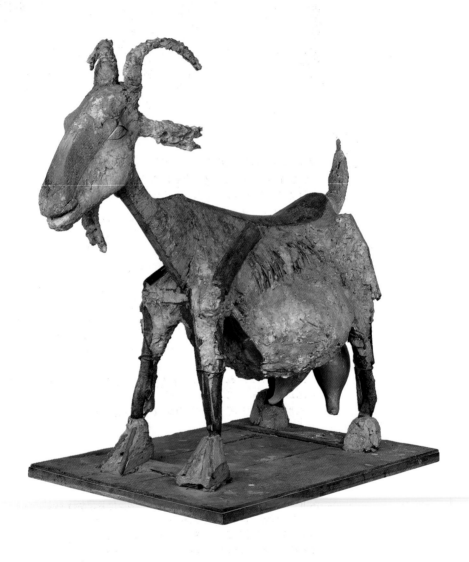

▲
The Goat, 1950,
Vallauris.
Original plaster
(wicker basket,

ceramic pots,
palm leaf, metal,
plaster):
120.5 x 72 x 144 cm.

THE GOAT

1950

Is this goat made of wood, clay, plaster or metal? None of the above, and all of them at once. It is an assemblage of objects that Picasso found lying about, from a palm leaf to an old tin.

The *Goat* came into being one day in 1950, in a studio in the middle of a field. For two years, after spending the dark days of the war in Paris, Picasso had been living in Vallauris in the South of France. He had rented an old perfume factory in Rue Fournas and turned it into a studio. It was there that he stored his pictures, the ceramics he was beginning to create, and the diverse range of materials that he picked up while he was out walking. Now that he had room, he could start making large works again. He returned once more to sculpture.

the art of recycling rubbish

For a work by Picasso, this *Goat* is amazingly goat-like. It is standing with its four legs apart, showing us its enormous belly. This is not because it is fat – its neck and legs are rather thin and its ribs are showing through its skin – but because it is pregnant.

The most surprising thing about this sculpture is what it is made of: plant matter, iron, cardboard, ceramic, wood, plaster and copper. It is as though Picasso were having fun recycling old junk.

In mythology
For the Greeks, the goat was sacred to many gods. But above all, it represented Zeus' wet nurse, Amaltheia. For Picasso it was the "female" animal *par excellence*. The goat is also the emblem of the town of Antibes.

65

◀ **Edward Quinn**
*Picasso between his
two goats: Esmeralda
and his goat sculpture,
here cast in bronze.*
Photograph.

Usually, Picasso would find objects by chance, prompting an idea for a sculpture. This time he knew in advance that he wanted to make a goat. As Françoise Gilot describes in her book *Vivre avec Picasso* ("Living with Picasso"), his first job was to collect his materials. On the way to his studio he stopped off at the ceramics dump, where he found pieces of pottery and metal. Anything heavy or hard to carry was loaded onto a pram, pushed by Françoise. An old wicker basket was just right for the goat's ribs.

The Goat, 1950,
Vallauris.
Oil and charcoal
on plywood:
93 x 230 cm.
▼

**The dialogue
between painting
and sculpture**
Picasso loved painting
best of all, but he
never stopped "taking
advice" from
sculpture, which
allowed him to
understand the
volume of objects, to
walk round them and
see them in three
dimensions.

66

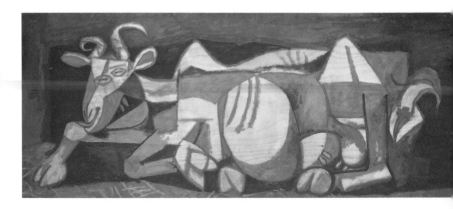

Two asymmetrical milk containers would make excellent feet, if the bottoms were removed and the handles kept. And what about that palm leaf he had picked up on the beach two years earlier? Its broadest part would make the forehead, the rest the spine. It just needed a little reshaping. To put all these objects together Picasso used wire and quick-drying plaster. The body quickly took shape.

a brilliant inventor

Picasso went on with his assemblage. He used vine stocks for the horns and beard, an old tin for the sternum, card dipped in plaster for the ears and two twisted copper pipes for the tail. For the back legs he found branches whose knots looked like joints. Nor did he leave out the genitals – a folded tin lid – and anus – a little tube inserted into the plaster.

This was not Picasso's first *Goat*; he had painted one in 1946. After 1950 he went on representing goats, in painted or sculpted still-lifes. In 1952 he illustrated a poem dedicated to him by his friend André Verdet with an etching of a goat. The sculpted goat was to travel round the world.

The Musée Picasso in Antibes
In 1946, Picasso was invited to paint for the Musée d'Antibes, which was to become the Musée Picasso. This is a magnificent space, with windows onto the Mediterranean. For the first time, Picasso painted pictures for a specific space.

Goat Skull, Bottle and Candle, 1951, Vallauris.
Painted bronze:
77.5 x 88 x 54 cm.

Like *The Goat*, this "sculpted still-life" was made in the Rue Fournas studio: a bicycle saddle for the skull, handlebars for the horns, a bottle and nails for the candle. Picasso had his sculpture cast in bronze, then retouched it with paint to emphasise its volume.

67

why so many animals in Picasso's work?

Picasso was always drawn to animals. At first he shared his studio at the Bateau-Lavoir with a white mouse. But he also had a cat and Fricka his dog and Monina the monkey. "Pablo would have liked a house full of animals" said Fernande Olivier in her book *Souvenirs intimes* ("Personal memories").

In the Grands-Augustins studio in Paris, Picasso lived with his dog Kazbek. In the Rue Fournas studio at Vallauris, he kept donkeys to graze the grass in his garden. At "La Californie" in Cannes, he was given the goat, Esmeralda, as a Christmas present. She climbed onto the back of the bronze goat in the garden, to Picasso's great joy.

a dove symbolising peace

But Picasso was not an animal sculptor or painter. He used animals, such as the bulls and horses that often appear in his work, to illustrate an idea or abstract notion. Of course, bulls and horses are both involved in bullfighting, but Picasso gave them a far deeper

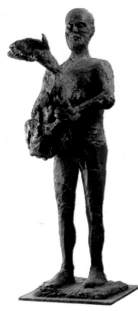

▲
Man with a Sheep,
1944, Paris.
Bronze:
222.5 x 78 x 78 cm.

Picasso made this without using ready-made objects. He was not seeking any effects of distortion or surprise.

Cat catching a Bird,
April 1939, Paris.
Oil on canvas:
81.6 x 100 cm.

Picasso said that he was not one of those artists who walk round with "a camera round their necks looking for a subject". His pictures were not recordings of events. This image of a cat catching a bird is all the more cruel because it shows a familiar animal in a monstrous light. The blue sky contrasts with the black colour, symbolic of death. Picasso inscribed the date, 22.4.39, ◀ at the top.

Bull's Head,
1943.
Original: saddle and
handlebars (leather
and metal):
33.5 x 43.5 x 19 cm.

A bicycle saddle for
a head, handlebars
for horns – the
metamorphosis is
perfect. Yet Picasso
would have liked to
have taken it further:
he wanted to throw
this head in the gutter,
have a workman find
it and turn it back into
a bicycle. "That would
have been wonderful.
That's the gift of
metamorphosis".

César,
*The Centaur –
Picasso with
Four Legs*, 1983.
Bronze:
4.45 x 1.82 x 5.20 m
3.8 tonnes.
At the Croix-Rouge
crossroads, Paris 6ᵉ.
(Original in the Musée
Picasso, Antibes).

Picasso often
identified with the
Minotaur. He would
certainly have liked
this homage by César,
portraying him as
a centaur.

meaning. The bull symbolised blind, brute force,
maleness and evil. The horse, on the other hand,
with its large belly, tended to represent the feminine.
Both animals figure in *Guernica*, as does the bird
beating its wings: "wings of the dove, wings of
love...". The dove is a symbol of purity, of taking off.
In 1949, Picasso made the lithograph *The Dove* as a
poster for the Congress of Peace in Paris. He also
called his fourth child Paloma.

a goat
representing life

For centuries, goats and lambs have been sacrificial
animals. *Man with a Sheep* recalls this ritual act. Is it
also a reminder that there is no creation without
sacrifice? "Each picture is a drop of my blood" said
Picasso. *The Goat* also means something else: we
should not forget that she is pregnant. Françoise
Gilot was pregnant twice, in 1947 and 1949. How
important this would be to a man well over sixty! Was
it not the sign of rediscovered youth? Like an ancient
sculpture, the down-to-earth aspect of this *Goat*
makes it timeless.

69

Illustration for
*Le Chef-d'œuvre
inconnu* ("The
Unseen Masterpiece")
by Balzac, 1931.
Etching.

This theme particularly
interested Picasso,
who made twelve
engravings of it.

▼

Illustration for
Cornet à dés
("The Dice Cup")
by Max Jacob, 1917.
Burin engraving
16.2 x 11.8 cm.

This book contains
a number of texts
inspired by Cubism. ▶

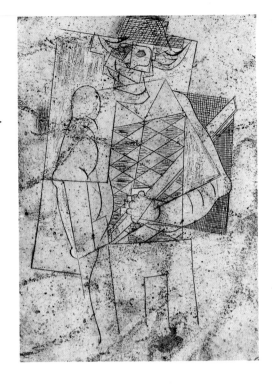

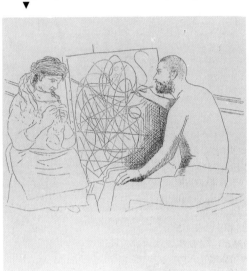

Illustration for ▶
Le Chant des morts
("The Song of
the Dead") by Pierre
Reverdy, 1948.
Lithograph.

This is a new type
of illustration. Instead
of creating separate
illustrations, Picasso
worked directly on
Reverdy's manuscript,
painting large red signs
like bloodstains.

Picasso, the artist and his century

I am an individualist, violently interested in everything around me". These words of Picasso's, spoken to Hélène Parmelin, perfectly sum up the contradictory aspects of the painter's character. They also no doubt explain the volume and range of his art, which seem to have been inexhaustible. Individualism implies the solitude and silence indispensable to creation, but Picasso also liked to live well and loved life in all its pulsating energy. He often worked late, even into the night, but he always made time for his friends.

Throughout his life, Picasso was surrounded by many people, particularly writers and poets. His taste for literature showed itself early. Before 1900 he frequented an avant-garde cabaret in Barcelona, *El quatre gats* ("The Four Cats"). It was there that he met the poet Jaime Sabartès, who became his secretary and his most faithful friend.

On arriving in Paris in 1901, Picasso made friends with Max Jacob and André Salmon, and, in 1904, with Guillaume Apollinaire, who became the great champion of Cubism. "Picasso's gang" met regularly in his studio at Le Bateau-Lavoir in Montmartre, whose door was inscibed: "the poets' meeting place". During these "meetings", collaborative projects took shape. Picasso started illustrating books. Between 1905 and 1974 he illustrated 156 works by contemporary and past authors. The last of these was published a year after his death.

Over time, Picasso's circle of poet friends widened. In 1910 he met Pierre Reverdy and in 1916 Jean Cocteau, who got involved in the Russian Ballet. In 1923, when Surrealism was flourishing, he met André Breton and

Brassaï, ►
photograph of
the friends' reading
of *Le Désir attrapé
par la queue* ("Desire
Caught by the Tail"),
1941.

The greatest literary
minds of the day
were there. From
left to right, Lacan,
Cécile Eluard, Pierre
Reverdy, Louise Leiris,
Zanie de Campan,
Picasso, Valentine
Hugo, Simone de
Beauvoir. In the
foreground, Sartre,
Camus and Jean Aubier.

▲
Picault,
photograph
of Picasso in a mask
during the film
Picasso-Rossif, 1950.

Once again Picasso's
fascination with
African masks is
revealed.

*On the Back
of the Immense
Slice of Melon*, ►
manuscript, 1935.
Indian ink and
coloured crayon.

With neither commas
nor full stops, the writing
is spontaneous and fast,
punctuated by new signs
invented by Picasso.

Paul Eluard, Louis Aragon, Georges Hugnet and Benjamin Peret. After the
Second World War, Michel Leiris and René Char also became close friends.
The links thus formed between all these artists reflect the high esteem felt
for Picasso by the greatest intellectuals of the 20th century. They all admired
him as a painter and sculptor, but also as a poet.

At the age of 54, Picasso temporarily abandoned painting and sculpture
for literature. We should not forget that, since the age of 20, in 1911, he had
been showing his need to communicate with words, phrases, letters and
numbers in his painting. He often used the word "language" when speaking
of painting. He said to Françoise Gilot, "Painting is never prose. It is poetry,
it is written in lines with visual rhymes. Painting is poetry".
On 18 April 1935, Picasso began to write, but he did not want to show
anyone what he wrote. In February 1936, the *Cahiers d'Art* devoted a special
issue to his work, publishing his poems in French and Spanish. As always,
Picasso liked to follow his own rules: spelling, grammar and punctuation
were rejected. In their place, he introduced arrows, asterisks, stars, spiders
and even triple inverted commas. Often written in Indian ink, these texts are
dotted with large blobs of ink and thick black lines, which give them a
graphic aspect. Like his painting, Picasso's writing is dynamic and gestural.
"It is a verbal flow in which his torrential imagination clutches at sensations
he has felt and its documentary value links it to the Surrealist texts' (Tristan
Tzara, *Picasso and Poetry*, 1954).

The most famous of the poems was inspired by *The Burial of Count Orgaz*,
by the Spanish painter, El Greco. In addition, Picasso also wrote two plays:
Le Désir attrapé par la queue ("Desire Caught by the Tail"), a dark piece
written in Royan in 1941 under the German Occupation, and *Les quatre
petites filles*, ("The Four Little Girls") of 1952. Michel Leiris organised a
public reading of *Desire Caught by the Tail* on 17 March 1944. The show was
resolutely Surrealist and took place in Leiris' flat in Quai Grands-Augustins,
with the century's greatest intellectuals for actors: Albert Camus, Michel
Leiris and his wife Louise, Jean-Paul Sartre, Simone de Beauvoir, Raymond

Picault,
photograph taken
during the filming
of *Picasso-Rossif*,
1950.

A paper cut-out
bird: a character
in *Don Quixote*. Again,
it could be said that
it takes more than
scissors to make
a cut-out. A simple
piece of paper is
transformed into
Don Quixote, the
film's main character.

▼

◀ *The Footballer*,
1961, Cannes.
Canvas cut and
painted:
59.5 x 49 x 14.5 cm.

From cut-outs,
Picasso moved
to flat sculptures
in canvas, made
in a similar manner.
In this way an
ephemeral work could
have a longer life.

Picault,
photograph taken
during the filming
of *Picasso-Rossif*,
1950.

The wife of one of
Picasso's collaborators
was chosen as an
actress. But only her
legs played the part,
transformed by
a few brush strokes.

▼

Queneau, Georges Hugnet, the publisher Jean Aubier and his wife Zanie de
Campan, who was the only professional actress. The play's success, and
that of Picasso, was phenomenal.

Circus, bullfighting, theatre – Picasso was drawn to the world of
spectaculars and shows. "Spain is the land of buffoons" he would say, often
posing as a clown, bullfighter or minotaur for photographers, who found
him an ideal model. He liked to be photographed at work and at home,
concerned about the image he would leave of himself and his work. He was
photographed by famous photographers such as André Villiers, David
Douglas Duncan, Brassaï, Robert Doisneau, Lucien Clergue, Arnold
Newman, Cecil Beaton and Edward Quinn. To Picasso, as he told Brassaï,
a photograph was like "a blood sample, to enable the analysis and diagnosis
of what I was at that moment".

Since the beginning of the 20th century, Picasso had been interested in
the "moving images" of cinema. In 1930 he began acting in films in which
he played himself, often wearing a mask. There again, he sometimes took
charge of everything.
In the summer of 1950, during the Festival of Antibes, he made his first film
in Vallauris. It was never shown in public because Picasso did not like it.
He was director, art director, costume designer, make-up artist and actor,
with Frédéric Rossif as his assistant. The camera has immortalised the
works that Picasso made for the occasion: cardboard masks, paper cut-outs
and "living paintings" on a woman's body. Picasso loved these ephemeral
works, as he did graffiti; they are also works of art, which come to life when
they are looked at.

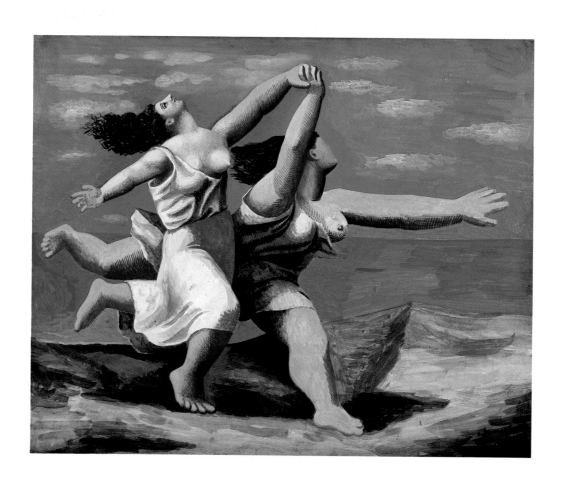

▲
The Race or
Le Train bleu,
summer 1922, Dinard.
Gouache on plywood:
34 x 42.5 cm.

THE RACE OR LE TRAIN BLEU

1922

Two women run along the beach, intoxicated by the wind and their freedom. When Picasso painted this little gouache he had no idea that it would end up on the stage.

In the spring of 1924, Picasso received a visit from one of his friends, Sergei Diaghilev, director of the famous Russian Ballet. Picasso had met him through Jean Cocteau in 1917 and the three of them were used to working for the theatre together.

While looking at Picasso's latest works, Diaghilev suddenly stopped in front of a painting on wood: two bathers, dressed in white robes like those of the Ancient Greeks, running wildly along a beach. Picasso had painted the gouache two years earlier in Britanny. It is a small picture (34 x 42 cm), but it gave Diaghilev an impression of immensity: sky, sea, sand, women, everything in it is monumental.

entering the stage

At that time, Diaghilev was rehearsing a new ballet, *Le Train bleu* ("The Blue Train"). He had asked a Cubist sculptor, Henri Laurens, to design the set, which was in itself a first. But Diaghilev had not yet chosen his drop curtain.

He had just found it: the curtain would also be the work of a Cubist; it would be Picasso's *The Race*.

A bad painter covers a theatre curtain, which opens on nothing. A real painter, while he's covering his canvas, raises it on a stage into which the eye and the mind plunge.
Jean Cocteau,
Picasso and Radiguet.

in what sense is Picasso also a classical painter?

◀ *The Race* (detail).

This woman is putting body and soul into a wild run. Her small head is completely out of proportion to her body. Her straight nose recalls the "Greek profile".

ink and blue: here combined for the first time are Picasso's favourite colours, those of the "rose" and "blue" periods. But they no longer have the same meanings. Pink is the colour of the women's flesh, of living things. Blue is no longer the blue of cold and sadness. It is the sea and sky, coolness and distance. In addition, Picasso had changed his technique: he had abandoned oil painting, which made the composition heavy, in favour of gouache, which is both light and opaque.

a few extra vertebrae

By painting these two dark-haired women, giving them massive, sculptural bodies and dressing them in white tunics fastened at one shoulder, Picasso wanted to introduce something of the classical art of Antiquity into his work.

He very much admired Poussin, the 17th-century French artist who reintroduced classical subjects inspired by mythology into painting. He was also a great admirer of Ingres, a neo-classical painter who lived in the 19th century.

Ingres was always ready to lengthen a back or neck by a few vertebrae to make the line more harmonious. He

Antiquity in painting
Since the Renaissance (16th century), painters had looked to Antiquity for an ideal of physical and moral beauty. In the 17th century, the period of classicism, painters like Poussin used mythological subjects to "elevate the soul". In the neo-classical period (late 18th and early 19th centuries), David and his disciples celebrated the virtue of the ideal man.

Picasso's colossi
In the 1920s, Picasso began to paint colossi: women and men of superhuman size. This is often called his classical or neo-classical period. It was during a trip to Italy in 1917 that he discovered the statues of Antiquity and of Michelangelo. Picasso's colossi also remind us of Renoir's fleshy women, whom he greatly admired.

thought nature should bend to art, rather than the other way round.

Like Ingres, Picasso defied all the laws of anatomy and even those of gravity. Both legs in the foreground and the outstretched arm of the right-hand bather are manifestly too long. The head and right hand of the bather on the left reach so far back that they seem ready to separate from the body. But the impression of movement is extraordinary. "You have to go further than movement to stop the image", Picasso once said. Here, he placed the feet of his two bathers on a single line, which rises to the left, as though both were making the same movement.

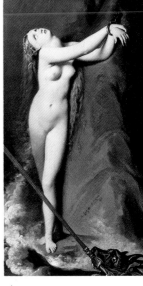

▲
Jean Auguste Dominique Ingres, *Roger delivering Angelica* (detail), 1819. Oil on canvas: 147 x 199 cm. The Louvre.

Here we find the same pose of abandonment and the same over-long, curved neck as in Picasso's picture.

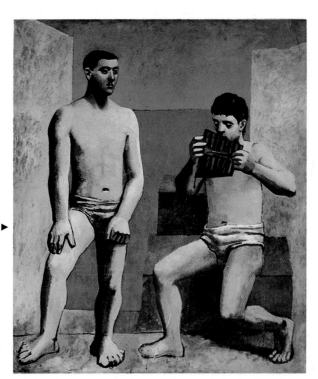

Pan Pipes, ▶ summer 1923, Antibes. Oil on canvas: 205 x 174.5 cm.

Are these figures really on a beach? A horizontal line crosses the space, marking the flat colour of a wall, as though this were a theatre set.

◀ Still from
Le Train bleu

Set design of Cubist
beach huts by Henri
Laurens. The entire
ballet unfolds on a
beach in the south
of France. The star
of the title, the Blue
Train, has already
left when the curtain
rises.

how does a picture become a stage set?

Why did Diaghilev choose this painting for his drop curtain? It is true that these bathers, at once heavy and dynamic, are not unlike the dancers of the Russian Ballet, who were known for their heavy bodies and thick joints. But what pleased Diaghilev most was the way in which they radiate a joy of running. He also liked the seashore setting: the themes of his ballet were sun-drenched beaches and sport.

too avant garde

The first performance of *Le Train bleu* took place on 20 June 1924, at the Champs-Elysées Theatre in Paris. The programme, illustrated by Picasso, had an impressive credits list: music by the contemporary composer Darius Milhaud, scenario by the writer Jean Cocteau, costumes by Coco Chanel, set by the sculptor Henri Laurens, choreography by Bronislava Nijinsky, sister of the famous Russian dancer. And the curtain was by Picasso. His *Race* had been transposed to an immense canvas by a decorator prince, Shervodshizé. Picasso attended the premiere and was fascinated by

Le Train bleu
A train linking Paris to the Côte d'Azur. After the First World War, wealthy Parisians would go to take the sea air for the summer. This wave of tourism brought with it a fashion for sport. People played tennis and golf. It was the cult of the body.

the show. Afterwards, he spontaneously decided to sign the curtain, dedicating it to Diaghilev. What was new in *Le Train bleu* was the contemporary nature of its subject. It shows the passengers of a luxury train, known for its magnificent interior decor. The entire ballet takes place on the beach; its characters are great athletes and frivolous people.

the audience felt targeted

However, the audience did not like this "danced operetta". They found the choreography chaotic, the music unfamiliar – Milhaud was only 32 – and the story shocking: seaside holidays are a delicate subject for affluent spectators. All in all, it caused a scandal. This reminded Picasso of the reception given to *Parade* seven years earlier.

Photograph of the costumes by Coco Chanel. "Make it more real than real", was her brief. So the dancers wore real sportswear, signed "Coco Chanel".
▼

Programme for the Russian Ballet, May-June 1924. After June 1924 the drop curtain for *Le Train bleu* was used to announce all subsequent performances by the Russian Ballet.
▶

GRANDE SAISON DE LA VIIIᵉ OLYMPIADE

XVIIᵐᵉ SAISON DE M. SERGE DE DIAGHILEW
sous le Haut Patronage de
LL. AA. SS. la PRINCESSE HÉRÉDITAIRE et le PRINCE PIERRE de MONACO

BALLETS RUSSES
DE MONTE-CARLO

CRÉATIONS

LE TRAIN BLEU
Ballet en un acte
Scénario de Jean COCTEAU
Musique de Darius MILHAUD
Costumes de CHANEL
Décors de H. LAURENS

LES FACHEUX
Ballet en un acte de B. KOCHNO d'après Molière
Musique de Georges AURIC
Chorégraphie de LA NIJINSKA
Rideau, Décors et Costumes de
Georges BRAQUE

LES BICHES
Ballet en un acte
Musique de Francis POULENC
Chorégraphie de LA NIJINSKA
Rideau, Décors et Costumes de
Marie LAURENCIN

UNE ÉDUCATION MANQUÉE
Saynète
Musique d'Emmanuel CHABRIER
Décors et Costumes de Juan GRIS

LES TENTATIONS de la BERGÈRE ou L'AMOUR VAINQUEUR
Ballet en un acte
Musique de MONTECLAIR (1666-1737). — Chorégraphie de LA NIJINSKA
Rideau, Décors et Costumes de Juan GRIS

RÉPERTOIRE

PETROUCHKA
Scènes burlesques en 4 tableaux
de MM.
Igor STRAVINSKY et Alexandre BENOIS
Musique d'Igor STRAVINSKY
Scènes et danses de Michel FOKINE
Décors et Costumes de M. Alexandre BENOIS

LE SACRE DU PRINTEMPS
Tableaux de la Russie païenne
de Igor STRAVINSKY et Nicolas ROERICH
Musique d'Igor STRAVINSKY
Chorégraphie de Léonide MASSINE
Décor et Costumes de Nicolas ROERICH

NOCES
Scènes chorégraphiques russes en 4 tableaux
Paroles et musique de Igor STRAVINSKY
Chorégraphie de LA NIJINSKA
Décors et Costumes de Mᵐᵉ N. GONTCHAROVA

PULCINELLA
Ballet avec chant en un tableau
Musique d'Igor STRAVINSKY
d'après Giambattista PERGOLESI
Chorégraphie de Léonide MASSINE
Décor et Costumes de PICASSO

PARADE
Ballet réaliste en un acte de Jean COCTEAU
Chorégraphie de Léonide MASSINE
Rideau, Décors et Costumes de PICASSO
Musique d'Éric SATIE

CIMAROSIANA
Musique de CIMAROSA
Chorégraphie de Léonide MASSINE

Le Rideau des Ballets Russes est de PICASSO

was Picasso abandoning Cubism?

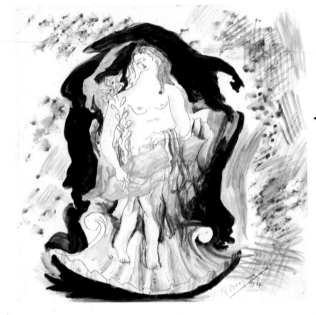

Picasso gained followers. Contemporary painters Juan Gris, Léger, Marie Laurencin, André Derain and Georges Braque were won over to the Russian Ballet. This sketch for a curtain was for *Les Fâcheux*, an adaptation of a play by the 17th-century French playwright Molière.

Parade
Parade was a ballet created by Sergei Diaghilev in February 1917, to music by Erik Satie with a scenario by Jean Cocteau, choreography by Leonid Messine and sets and costumes by Picasso, who had never worked for the theatre before. It was a complete failure with the public, but for the first time the poet Apollinaire used the word "surrealism", which would be taken up by his successors. Picasso was involved in three other shows with the Russian Ballet: *The Three-Cornered Hat* in 1919, *Pulcinella* in 1920 and *Quadro Flamenco* in 1921. *Le Train bleu* was the last.

The first of the Russian ballets on which Picasso worked was called *Parade*. But Picasso the set designer was not very well thought of by his Cubist-period friends.

"painting a set was a crime"

Jean Cocteau recalls: "I took him in a direction in which his circle didn't like to think he would follow me. Montmartre and Montparnasse were under a dictatorship [...] Objects that could be laid out on a café table and the Spanish guitar were the only pleasures permitted.

Painting a set [...] was a crime. The worst thing was that we were supposed to go and meet Sergei Diaghilev in Rome and the Cubist code forbade any journeys beyond the north-south trip from Place des Abesses to Boulevard Raspail". The Cubists were all the more surprised because, although they knew about Picasso's passion for the circus and popular art in general, until then his taste for bareness and austerity had kept him away from the luxurious world of the theatre.

In fact, Picasso's life had brutally changed with the
First World War. He had stayed in Paris and had been
separated from his friends. In particular, this marked
the end of his Cubist adventure with Braque. In 1915,
he lost his dear Eva to tuberculosis – to whom he had
given the name because to him she was first among
women.

the "duchess period"

On the other hand, Picasso's circle of friends was
widening. Diaghilev and Cocteau introduced him to
the musicians Erik Satie, Igor Stravinsky and Darius
Milhaud, and also to dancers, including the Russian
Olga Kokhlova, whom he married in 1918.
His mode of life was also changing. He left the poor
neighbourhoods of Montmartre and Montparnasse to
live in Rue de la Boétie, near the Champs-Elysées,
where his new art dealer, Paul Rosenberg, lived. Yet
this "duchess period", as Max Jacob called it, never
prevented him from continuing his researches into
painting.

Never satisfied
When Picasso left
for Rome, his style
had already evolved,
since Cubism did not
provide an answer
to all his questions.
Picasso always had
questions. Although
he might launch a
movement, he always
abandoned it in the
end. Throughout his
career we see the
fruit of his many
experiments.

▲
*Costume design for
The Acrobat,*
1917, Rome.
Watercolour and
lead pencil on
watermarked paper:
28 x 20 cm.

Picasso designed
the set and costumes
for *Parade* as well
as the drop curtain.

◄ Photograph of the
making of the drop
curtain for *Parade,*
1917, Rome.

In 1917 Picasso was
involved in making
the drop curtain,
set and costumes for
Parade. For *Le Train
bleu,* the curtain was
made by a set decorator.

83

Self-portrait,
autumn 1906, Paris.
Oil on canvas:
65 x 54 cm.

The geometric forms
of the body and stylised
lines of the face recall
a primitive mask. ▶

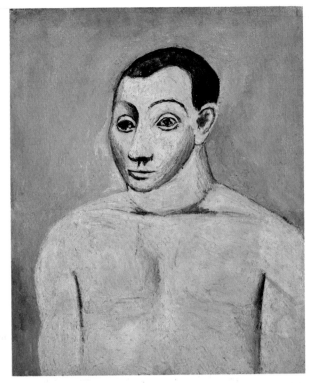

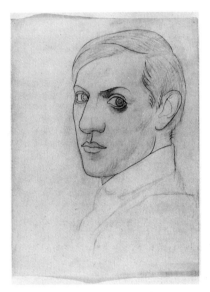

▲
Drawing, *Self-portrait*,
1917-1919.
Lead pencil and
charcoal on paper:
64 x 49.5 cm.

Picasso parted
his hair, but on
the other side.

Self-portraits ▶
and studies, 1897-1899.
Black crayon,
pen and ink
32 x 24 cm.

Picasso was as much
a master of the realist
technique of pencil-
drawing as he was
of ink-drawing.

Picasso looks
at himself

Of all the artists of the 20th century, Picasso is certainly the best-known to the general public. There are books, documentary accounts and films about him. We have seen him from all angles: painting, sculpting or working in his ceramics studio, at home surrounded by his children, or with his friends. Who is not familiar with the piercing gaze of his large brown eyes, whose pupils are so dilated they appear black?

Strangely, it is through the camera's eye that we know Picasso best. For although he was so interested in the representation of human faces, never tiring of observing their slightest expressions, he rarely portrayed himself. "Portraits of me are rare; I have not spent much time with my own face" he told the photographer Brassaï. For a self-portrait, a painter needs a mirror. Picasso hated mirrors: they are "the frame of the face that reflects boredom" he said in 1937; in them he saw "the black light of ice".

Boredom and death were two things from which Picasso kept away throughout his life. His dislike of mirrors went back to 11 November 1918, the day that one of his closest friends, Guillaume Apollinaire, died from a war wound. When Picasso heard the news, he was in front of a mirror. No one will ever know what he saw in its reflection, but that day he decided not to make any more-self portraits. The few exceptions are so little like him that it is easy to forget that they are self-portraits.

*Study of a hand,
the left hand,*
June 1920, Paris.
Gouache on
watermarked paper:
21.3 x 27.3 cm.

The hand
is the painter's tool,
so here Picasso
gives us part
of himself –
his other face.

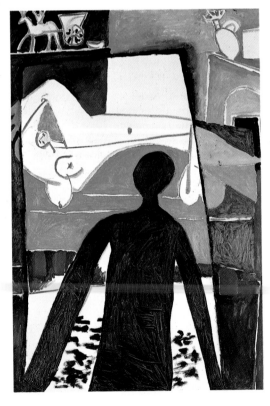

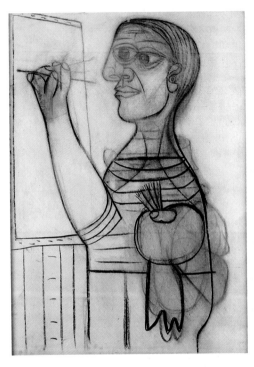

The Artist at his Canvas,
22 March 1938, Paris.
Charcoal on canvas:
130 x 94 cm.

A "smudged" self-
portrait. Before
photographing this
canvas, D. D. Duncan
tried to dust it.
Unfortunately, a
layer of charcoal
that Picasso had
forgotten to fix
was brushed away.

The Shadow,
29 December 1953,
Vallauris.
Oil and charcoal
on canvas:
130.5 x 96.5 cm.

The painter
(the shadow) moves
towards the woman
(the light), through
the canvas. Abandoning
his brush and palette,
he exists only through
his own work.

Since the Renaissance, most artists have made self-portraits. No doubt they choose to do this in order to leave an image of themselves to posterity. The first self portraits date from the 16th century, when painters and sculptors were no longer treated as simple artisans, but as artists. Their contemporaries saw their creations as having a divine element. This was why the German painter Albrecht Dürer, who made more than 50 self-portraits, identified himself with Christ in one of them.

A century and a half later, painters had stopped representing themselves as all-powerful beings. When Rembrandt painted himself at the age of 54, he was not trying to give himself an "honourable" image. On the contrary, he painted himself unshaven, old and poor; but he is in front of his easel, brushes and palette in hand. The painter's dignity is to be found in his work. In the 19th century the tradition was maintained by Van Gogh. Each of his self-portraits poignantly expresses the anguish and loneliness of the painter.

Self-portraits are often fascinating, probably because of the gaze that seems to come through the canvas. In practice, the painter's eyes are never turned towards the person looking at the painting, but towards himself, through the medium of the mirror in which he sees himself. The mirror is an indispensable tool for the painter. It was when the mirror began to be manufactured more successfully, in the 16th century, that self-portraits became a fashionable artistic genre.

Self-portraits gradually disappeared from painting in the late 19th century, probably due to the development of photography and then cinema. But can a camera and lens really replace the painter's eye?

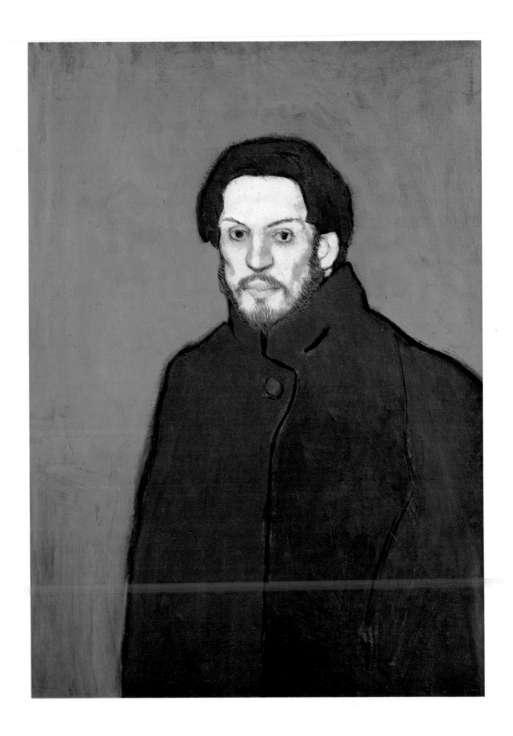

SELF-PORTRAIT

1901

<u>In this self-portrait, Picasso looks like an old man. Yet he was only twenty. His large, dark eyes, sunken cheeks and defeated expression betray his inner state: it was night and winter, both outside and inside.</u>

It was the end of 1901. For a year, Picasso had been living between Barcelona, home of his youth, and Paris, which had become a magnet for Spanish artists. He had moved into a studio at 130 Boulevard de Clichy, near Montmartre, the meeting place for the artists of the time. There were few buyers and times were hard. It would be a bitterly cold winter.

solitude and silence

For Picasso, three years of great pessimism were just beginning. This attitude was to infuse all his work. He painted dark subjects, sometimes filled with despair, and abandoned bright colours, drowning his painting in blue. In this work, where no palette or brush indicate that this is the portrait of a painter, a pale, thin face appears in the darkness of the canvas. His body is turned three-quarters towards us, as though he had just come into the space of the picture from the right, but his face is painted from the front. The look we see here is that of Picasso regarding himself. The entire composition centres on this face – the face of a mature man. Yet Picasso was only twenty.

**The mood
of the times**
In France and Spain, spleen was in fashion: pale young people languished with a disgust for life they could not explain. Artists, who often lived in poverty, embodied the mood of a whole generation.

◀ *Self-portrait*,
late 1901, Paris.
Oil on canvas:
80 x 60 cm.

89

why such high contrast?

◀ *Self-portrait* (detail).
Eyes outlined in a cold colour (blue or green), have a deeper expression. A touch of warm colour (red) on the lips gives life to the face.

Picasso used simplicity to the full. Wearing a firmly buttoned coat with his collar up, he looks as though he has just come in from outside. Yet there is nothing to tell us where he is. The background is all of a piece, with no horizon.

Nor is there any perspective, which was not in itself new: the artists of the late 19th century, particularly Gauguin, Degas and Van Gogh, had already rejected the traditional rules of perspective. Rather than the external world, it was the inner life that Picasso was trying to portray.

Our eyes are drawn to the very pale face, which contrasts with the hair and with the featureless – or

An Expressionist painting
It is cold and dark, and Picasso is sick; nothing in the painting tells us this, but everything expresses it. This is what is called an Expressionist painting. Here again, Picasso demonstrates his originality. At this time the Expressionists, known as the *Fauves* (wild beasts), tended to use brilliant colours.

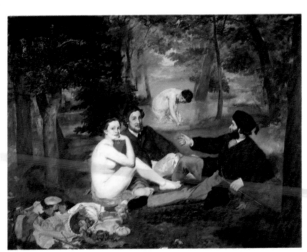

◀ **Édouard Manet**, *Le Déjeuner sur l'herbe*, 1863.
Oil on canvas: 208 x 264 cm. Musée d'Orsay.

This painting – so famous today – shocked the public of 1863. The contrast between the crude colours without variation, figures flattened by unified colours and a black outline, and the rejection of perspective were all seen as a provocation.

*The Death of
Casagemas*,
summer 1901, Paris.
Oil on canvas:
27 x 35 cm.

Casagemas was a
friend of Picasso's.
It was his death that
led Picasso to paint in
blue. Here the yellow-
green colours and short,
sharp brush strokes
show the influence
of Van Gogh.

What is flat colour?
A way of using colour
uniformly, without
variation of shade,
to give a flat
appearance to
the painting. Each
colour has different
shades, from darker
to lighter. By shading
the colours down
or up a painter can
suggest volume and
depth. This, Picasso
refused to do.

"monochrome" – blue of the background. Picasso was
playing two different styles against each other.
By reducing them to flat shapes, outlined in a darker
blue, he has simplified the coat and hair. He has used
a flat, navy blue, mixed with indigo. With such
"stylisation", we cannot see the texture of the cloth. On
the other hand, he has carefully worked the face – the
element that interests him the most. Bluish shadows
give it shape. The brush technique is careful and shows
in-depth work.

*Le Déjeuner sur
l'herbe, after Manet*,
June 1961, Mougins.
Oil on canvas:
130 x 195 cm.

This is not a copy,
it is a free study.
The adaptation of key
works of the past, and
dialogue with former
masters, enabled
Picasso to transpose
a well-known subject
using a new sort
of painting.

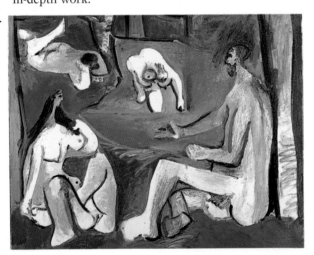

what was the "blue period"?

La Vie ("Life"),
1903, Barcelona.
Oil on canvas:
197 x 127.3 cm.
Cleveland Museum.

This picture, the
largest of the "blue
paintings", was
preceded by many
studies and sketches.
The self-portrait that
Picasso originally
intended (revealed by
X-rays) was replaced
by the portrait of
Casagemas. The
couple and the mother
and child suggest
a very sad existence.
On the other hand,
the pictures in the
centre prove that
there is lasting life
in art and creativity.

**How should blue
be used?**
Although it would be
their actual, or "local"
colour, brown is not
used to paint distant
mountains. Blue is
generally used,
because it gives more
depth and distances
the background.

Between the end of 1901 and 1904, blue invaded all of Picasso's paintings. Blue is the colour of the sea and sky, of night, distance and depth. But it also the colour of ice, cold, loneliness and death.

"It was when I was thinking that Casagemas was dead that I started painting in blue", Picasso told the historian Pierre Daix. On 17 February 1901, the Spanish painter Casagemas, a close friend of Picasso's, committed suicide in Paris because of an unhappy love affair. Picasso, very upset by this, painted five pictures about the death of his friend.

Photograph of
the Bateau-Lavoir,
with annotations
by Picasso showing
his studio.

The Bateau-Lavoir,
(which owed its name,
Washtub-Boat, to Max
Jacob), was formerly
called "The Trapper's
House" because of its
wooden frame. It was
at 13 Rue Ravignan
in the heart of
Montmartre.

Picasso was not the only one to give a particular
meaning to blue. At the same time, a group of German
Expressionist painters called *Der Blaue Reiter* ("The
Blue Rider"), was using this colour to express what the
Russian painter Kandinsky called "the spiritual in art".
Research relating to blue continued throughout the
20th century, particularly with the French painter Yves
Klein, who went so far as to work entirely in blue
monochrome.

suffering in blue,
love in rose

When Picasso moved into his studio in the Bateau-
Lavoir in May 1904, it marked the end of the blue
period. He needed silence and solitude to work, so he
painted at night, by the light of an oil lamp or candle,
standing the painting on the ground. His studio was
poorly furnished, but full of "easels, canvases of all
sizes, tubes of colour scattered on the floor, brushes,
containers of oil, a bowl for acid for etchings, no
curtains [...] Large unfinished pictures would stand in
the studio, where everything spoke of work, but work
in such a mess!"
This was how Fernande Olivier described Picasso's
studio as it was when she first saw it in 1904.
Fernande gave Picasso back his taste for life. Thanks
to her, he gradually gave up monochrome blue. In
1905 the rose period began with *The Saltimbanques*.

Kees Van Dongen,
Self-portrait in Blue,
1895.
Oil on canvas:
92 x 60 cm.
Musée National
d'Art Moderne
(held at Musée
d'Orsay), Paris.

We see the solitary
painter's silhouette
against a window.
The Expressionist
(Fauve) painter, Van
Dongen, was a close
friend of Picasso's.
In 1906, he also moved
into the Bateau-
Lavoir. This is one of
the rare examples in
which he uses a single
dominant colour.

93

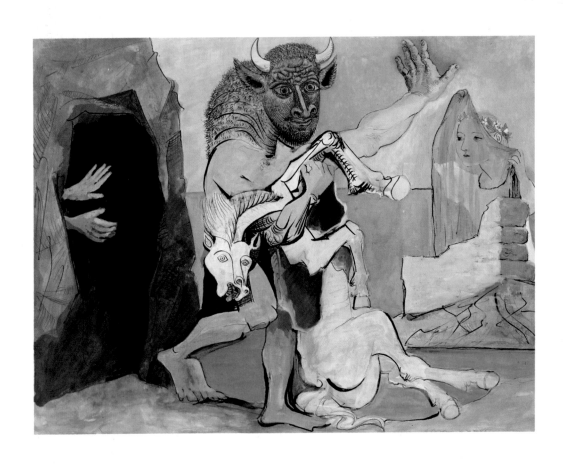

*Minotaur and Dead
Mare before a Cave
facing a Girl in a Veil*,
6 May 1936,
Juan-les-Pins.
Gouache
and Indian ink:
50 x 65 cm.

MINOTAUR
AND DEAD MARE
1936

<u>In 1933, a new theme – the minotaur – appeared in Picasso's work. This monster from Greek mythology allowed Picasso to tell a new story: that of his own life.</u>

February 1936. For some days, Picasso had been by the sea with Marie-Thérèse Walter, who had been his model and companion since 1927, and their daughter Maïa. Picasso had everything to make him happy. But things were not so simple. Picasso was married and had separated from his wife Olga, who refused to divorce him. His life had become a nightmare, caught between his duty to Olga and his love for Marie-Thérèse. He was paralysed by doubt. Since May 1935, he had been unable to sculpt or paint and could only express himself in writing.

a rather sympathetic monster

Only through art could he get out of this situation. Here, at Juan-les-Pins, Picasso gradually returned to painting, making a powerful and mysterious gouache. A monster has come out of a dark cave by the sea, dragging a dead mare, held tightly in his right hand. With his other arm and raised hand he seems to be pushing something away. He is moving towards a girl wearing a crown of flowers, who is watching the scene from behind a veil. This monster is a minotaur – a man with the head of a bull. A strange monster, his eyes are almost gentle, his step hesitant.

The Minotaur, a character from Greek mythology
Half bull, half man, the Minotaur was the offspring of Pasiphae, wife of the powerful King Minos of Crete, and a bull. To avenge the death of his son Androgeus, who was killed by a bull belonging to the King of Athens, King Minos decided to imprison the Minotaur in a labyrinth, from which it was impossible to escape. To feed it, every nine years the Athenians had to provide seven young men and women. The story ends unhappily for the Minotaur, which is killed by Theseus, an Athenian hero.

how
did
Picasso
construct
his
picture?

This picture reads from left to right, like a written text. It is constructed in three parts: the most important section consists of the Minotaur and mare in the centre; to the left is the dark entrance of a cave; to the right is a girl dressed in white. In this way, our eye is drawn from the darkness of the cave towards the light represented by the girl.

speaking hands

Two strange hands – the fine, white hands of a woman – are emerging from the cave. They seem to be imploring, begging for something from the Minotaur, who has turned his back and is walking away. The arm around the mare is strong and muscled, obviously that of a man. But why is the Minotaur raising his other arm, as though threatened?

The danger can only be coming from the girl on the right, who has the features of Marie-Thérèse. She herself seems to be in the power of the Minotaur's hand, which is too big in relation to the rest of his body

◀ *Minotaur and Mare* (detail).

The bull's head is painted in gouache and Indian ink. Picasso has covered it with a network of black lines. The hairy neck, the ears and horns are those of a bull, but the wide eyes are Picasso's.

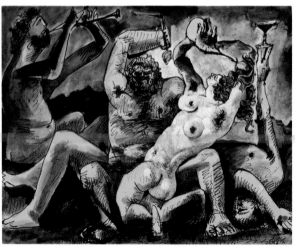

◀ *Bacchanal*, 1955. Indian ink and wash, retouched with white gouache: 50 x 65.5 cm. Jacqueline Picasso *dation*.

This gouache shows another scene inspired by Antiquity in which the faun, Nessus, with a dark, animal's face, seizes hold of a woman playing the tambourine, whose rounded forms recall those of the dead mare.

The Minotaur's Corpse dressed in a Harlequin Costume (drawing used as the design for the drop curtain for *14 July* by Romain Rolland), 28 May 1936, Paris. Gouache and Indian ink: 44.5 x 54.5 cm.

Here, the Minotaur is dead. He is certainly the victim and is dressed in Picasso's favourite costume – as Harlequin.

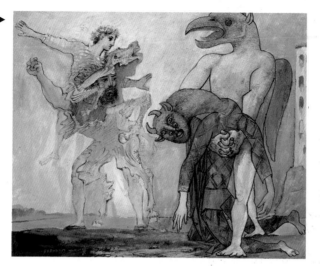

and seems almost unreal. This hand is, moreover, the only part of the Minotaur's body that Picasso has taken time over.

To the right, in front of the girl, Picasso has painted an enormous fist. What is this severed hand doing here? Is it the remains of an ancient sculpture? What did Picasso intend it to mean? The mystery remains. Picasso never explained it.

Picasso's drawings
Picasso left over 7,000 drawings. He used every technique – black crayon, coloured crayon, charcoal, lead pencil, Indian ink, watercolour, pastel, gouache, oil – and all kinds of support – drawing paper, letter paper, brown paper, envelopes, newspaper and cigarette packets.

killer or victim?

The central pair, Minotaur and mare, form a couple: male and female, darkness and light, brute force and weakness. They are surely monster and victim. Yet the Minotaur seems to have saved this mare from danger by taking her out of the dark cave. Is he really a murderous monster? Or is he himself the victim?

In fact, as when he painted himself as Harlequin, Picasso has given himself a new disguise here. The Minotaur is another of Picasso's masks.

How can anyone enter my dreams, my instincts, my desires, my thoughts, which have taken so long to develop and come into the light, and, particularly, find in them what I may have put there against my will? Picasso.

97

why a minotaur?

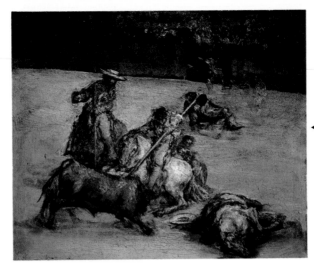

◄ **Francisco Goya**, *Bullfight*, 1825. Oil on canvas: 38 x 46 cm. Prado Museum, Madrid.

If Spain is the supreme land of the bullfight, Goya is its artist. Besides many paintings, he made a whole series of engravings of bullfights in 1816.

The Minotaur and Surrealism
1933 saw the first issue of *The Minotaur*, the Surrealist magazine. The Surrealists saw the Minotaur as having a dark power, capable of breaking all established laws. Michel Leiris, a close friend of Picasso, regarded literature as a "bullfight" and a book as a ritual act.

A bullfight is a ritualised ceremony, in which the spectators feel close to the bullfighter. Picasso admired the courage of these men who risk their lives in the ring. As a young boy in Spain, Picasso was taken by his father to see bullfights. His first known picture, painted in 1889 at the age of eight, portrays a young toreador.

a lover's tragedy

But Picasso had always felt as close to the bull as he did to the bullfighter. He was fascinated by the Minotaur because in it he saw both the man and the beast. When he depicted himself as the Minotaur, he was showing his two sides: the victorious bullfighter and the defeated bull. He was both winner and loser, the one who inflicted pain and the one who suffered it. With women he also acted as both the lover and the one who kills.

This is one of the keys to help us understand *Minotaur and Dead Mare Before a Cave*. Picasso was expressing the complexity of his love life and the ambiguity of his feelings towards Olga and Marie-Thérèse.

Here the Minotaur – "human, all too human", as Picasso used to say – has escaped from his labyrinth. But the hands emerging from the dark cave could well be those of Olga, trying to keep him imprisoned. Or

Bullfight: Death of the Bullfighter, ► 19 September 1933, Boisgeloup. Oil on wood: 31.2 x 40.3 cm.

The red cape spreads like a pool of blood between bull and horse. It is the victory of the bull, masculinity and evil. The horse, with its belly ripped open, is symbolic of the feminine. Picasso would use a similar pose for the horse in *Guernica*.

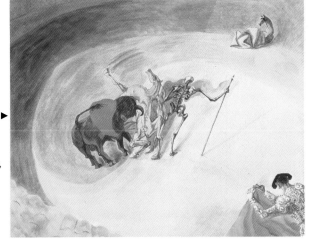

Paul Masson, ▶
Jet of Blood, 1936.
Oil on canvas:
100 x 127 cm. Musée
National d'Art Moderne,
Paris.

In 1935, André Masson
became fascinated by
bullfighting and the
Minotaur, as Picasso
was. "It's an imaginary
bullfight" said Masson,
who is here using the
traditional symbol of
death – the skeleton.
The circular ring recalls
the whirlwind of life
or unavoidable fate.

are they the conscience of an unfaithful husband? The dead mare he holds in his arms can only be Marie-Thérèse, but Marie-Thérèse is also the girl on the right, symbol of innocence and purity.

Why is the girl behind the sculpted hand? Why does the Minotaur seem to want to push her away? Is he afraid of innocence? Picasso's painting is autobiographical, but it remains very mysterious.

Bullfighting and literature
In the 19th century, Prosper Mérimée described the bullfight in his *Voyage en Espagne* ("Journey to Spain") as "the finest spectacle that man can imagine". In the 20th century, bullfighting became a symbol, particularly in the work of Hemingway, Garcia Lorca and Cocteau. "The bullfight is the spectacle in which Spanish poetry fearlessly expresses itself. It is both spectacle and science", said Jean Cocteau in *The Bullfight of 1 May*.

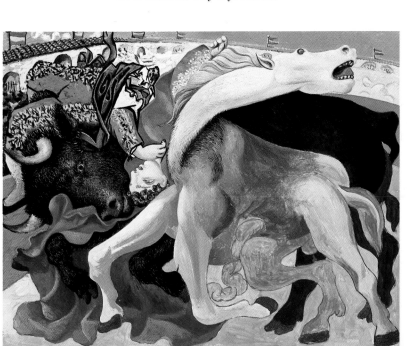

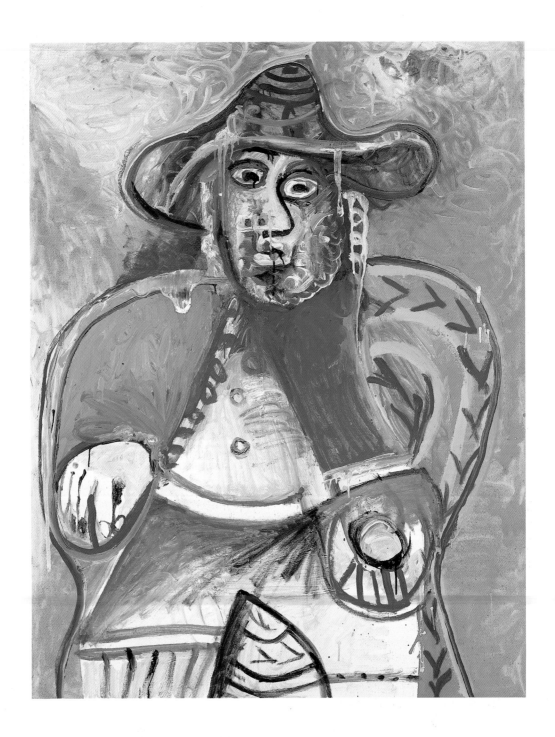

OLD MAN SEATED

1970

Loud colours, dribbling paint, a crazed expression: there is so much violence in this picture! Picasso was 89 when he painted this image of old age. It is an astonishing way to cry out his desire to live.

The summer of 1970 was coming to an end. Everything Picasso had done in the preceding year was on display in a huge exhibition in Avignon, at the Palais des Papes. There were thousands of visitors. During this time, Picasso had gone to Mougins with Jacqueline. He was almost 90 and still had much to say. On 26 September he began a picture that he would not finish until November in the following year.

the man with one hand cut off

Yet this picture does not look like a carefully elaborated work. An old man is sitting in an armchair against a background of burning orange. Under a wide-brimmed hat, his head has sunk between his shoulders and his face is haggard. The whites of his eyes, which completely surround the black irises, give him a crazed look. Drips of paint run down his face to his beard. His turquoise waistcoat, reminiscent of the matador's "suit of light", is open over his belly and navel. His right hand seems to be resting on the arm of a chair, but where the other hand should be, we see a horrific stump.

Picasso Museums
Two museums dedicated to Picasso were established during his lifetime: the Antibes museum and, more importantly, the Museo Picasso in Barcelona (Spain), which holds a major collection of his early works. Today, there is also the Musée Picasso in Paris. But almost every museum in the world, large or small, has works by Picasso.

◀ *Old Man Seated,*
26 September 1970-14 November 1971, Mougins.
Oil on canvas: 145.5 x 114 cm.

who can we see in this picture?

We usually associate a "sad" picture with dark colours. Here, the opposite is true. Picasso has chosen bright colours for his old man: a fiery orange next to emerald green and cobalt blue. He makes great use of contrast: the black lines around the forms contrast with the drips of white paint, the white background of unpainted canvas visible in the left hand, the belt, and the area around the stump of the arm. Before Picasso, no-one but Van Gogh had been able to create such a contrast between a sad subject and exuberant colour. Picasso was increasingly tending to leave the canvas white. Back in 1945 he had said to his friend Brassaï, "If it goes on like this, soon I'll be putting my signature and the date on completely untouched canvases... An untouched canvas is so beautiful, isn't it?" Picasso did not realise how accurate this was: contemporary painters have done just that.

a painter's memory

In this picture, Picasso seems to be paying homage to certain great painters: to Cézanne, for example, and his straw-hatted gardener Vallier, or to Van Gogh, who cut his ear off – rather than his hand, as here – in a fit of madness. But it could also be to the painter, Renoir, who could no longer hold a brush or palette at the end of his life because his fingers were so crippled with arthritis.

The old man is so settled in his armchair that he seems to have adopted its shape. On the left, we see his round shoulder and the sleeve of a turquoise waistcoat. But

Cézanne and Van Gogh

Both painters began their careers with very dark paintings, in which black played an important part, but under the influence of Impressionism, both changed to a palette of light, brilliant colours. Then, while Cézanne sought to convey an ideal pictorial space, Van Gogh moved towards Expressionism.

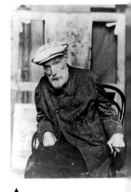
▲ Photograph of Renoir in a wheelchair (1912).

102

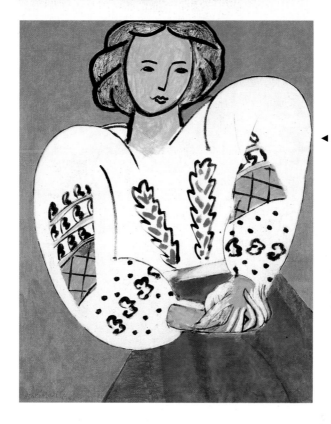

▲ **Henry Matisse**,
The Romanian Blouse,
1940.
Oil on canvas:
92 x 73 cm.
Musée National d'Art
Moderne, Paris.

Picasso and Matisse
shared a taste for
simplicity and
economy of means,
which enabled them
to get to the essence
of things.

Drawing from the
1912 photograph
of Renoir:
61 x 49 cm.

Renoir's later work
had a considerable
influence on Picasso,
particularly during his
"neo-classical" period.
Here, he is interested
in the man, the old
Renoir.
▼

on the right, all this has disappeared, replaced by the back of the chair. Another memory returns, not so distant this time: that of *The Romanian Blouse* by Matisse, Picasso's rival and friend, who had been dead since 1954.

"painting with profanities"

More than ever, Picasso is making painting "speak" here. This image of the old man is, of course, the painter's story. The time has passed when Picasso would put on the disguise of the Minotaur to struggle against dark forces. Now he is alone, he no longer hides; it is death that he must face.

The way in which he reveals his memories may seem shocking, sometimes even vulgar. But, as he himself said, "You have to know how to be vulgar, painting with profanities".

*Picasso always used
painting like a personal
diary.*

103

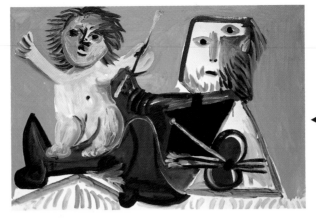

in what ways was Picasso still innovating?

"Bad painting" was
the name given to a
kind of "uncontrolled"
Action painting in the
1980s. Was Picasso
its father?

The older Picasso grew, the less he drew his forms. Once again, he invented a new way of painting, heralding the art of the 1980s known as "bad painting". Picasso generated forms not by drawing, but using paint itself. Often it was thickened, sometimes flattened, and contrasted with the brilliant white of the canvas. He painted using rapid, energetic strokes and liquid paint that would run down the picture: "It's stronger than me!" Emphasising the physical act of painting in this way and letting the paint run, is a characteristic of "Action painting", which appeared in the 1940s. Its first representative was the American artist, Jackson Pollock.

Picasso's signature
Why did Picasso
choose his mother's
name? *It was more
unusual, it had a better
sound than Ruiz. And
it's probably for those
reasons that I adopted
it. Do you know what
I liked about the
name? It was
the double 's', quite
unusual in Spain. [...]
And have you noticed
the double 's' in
the names Matisse,
Poussin or Douanier
Rousseau?*

no time to pussyfoot around

It is hard to believe that this picture was made by the same artist who produced the *Self-portrait* of 1901 and the *Minotaur and Dead Mare*. Picasso seems to have forgotten everything, constantly repeating the same schematic signs and motifs: stripes, stars, arrows, spirals, infinity symbols, and so on.
Despite his age, Picasso still felt very "alive". He was still filled with desire, love, a taste for beauty, youth. Yet through his painting he constantly spoke of the body's disintegration.

In 1970 he had only three years left to live, and ever more things to say. In this race against time, *Old Man Seated* immediately shows us the essentials, hiding nothing, with a minimum of means. Picasso no longer has time to be modest or discreet.

art is never chaste

No barriers could restrain his vitality now. This picture shows not the madness of an old man in his second childhood, but real liberated youth bursting forth. The old man is seen against a flaming orange background.

This is no doubt a man's final sunset; but it is also the dawn of painting. "Painting still needs doing" said Picasso in his last moments.

◄ **Willem de Kooning**, *Woman*, c. 1952. Charcoal and pastel on two sheets of paper stuck together: 74 x 50 cm. Musée National d'Art Moderne, Paris.

"I draw as I paint and I don't know the difference between painting and drawing". Like Picasso, de Kooning destroys and dislocates the woman's body, recreating it by emphasising those elements that seem to him to evoke it. He paints with large movements, arbitrary colours and "smudged" drawing. He was part of the artistic trend called Action painting.

Picasso's palette-chair. Photograph.

The palette – the painter's "laboratory" – figures in many of Picasso's pictures. But he never used one. He preferred his old wooden chair, which went with him everywhere.
▼

105

▲
Brassaï,
*Picasso in his studio
at Rue des Grands-
Augustins, with his
painting* Women
at their Toilette.
Photograph.

*I took his portrait
in front of this
unfinished picture.
The folds of his
raincoat look like
part of the "collage"
and an arm on the
picture belongs to
his body.*
Brassaï, 1964.

A step-by-step analysis

WOMEN AT
THEIR TOILETTE

1938

▲
Brassaï,
*Picasso in his studio
in Rue des Grands-
Augustins* (detail).

When Guernica was taken to the Universal Exhibition, the studio wall in Grands-Augustins was left empty. To fill it, Picasso decided to paint *Women at their Toilette*, an enormous picture that would cover its entire surface. But this work was to have a different destiny.

A Cubist cartoon
The only one of its kind in Picasso's work, this tapestry cartoon sums up all the periods of his art. But it particularly echoes his Cubist experience, at a time when he seemed to have left it long behind.

For some time, Picasso had been interested in tapestry, an art-form that had long been neglected. One of his friends, Marie Cuttoli, asked contemporary painters to make cartoons (in other words, the pictures to be woven), for her art gallery. Picasso had an idea: why not make collages with the material normally used for decorating walls – wallpaper?

half tapestry, half wallpaper

So he cleaned out the wallpaper shops! All patterns interested him: flowers, geometric forms, imitation wood or stone, anything. He would cut and paste, then finish by drawing a few black lines with his brush. When his picture was complete and ready to leave the studio to become a tapestry, Picasso could no longer bear to part with it. The project was abandoned. In 1967, nearly thirty years later, André Malraux, Minister of Culture, returned to the idea, commissioning the famous Gobelins tapestry workshop to do the weaving. Two tapestries of the design were woven in black and white and two in colour. One was sent to Picasso's house in Mougins.

Women at their ▶
Toilette, 1938, Paris.
Cut and pasted
wallpaper and oil on
canvas: 299 x 448 cm. 107

The subject

• This is universal and traditional in art, but treated in an unusual way.

Technique

• Picasso made a collage. The first collage dates from his Cubist period.

• For his "tapestry cartoon", Picasso used wallpaper, sometimes called *tapisserie*, (tapestry), in French. He got the idea from the pun.

• Picasso has exploited some of the wallpaper patterns: "stone", "brick" and "wood" have been used to portray walls and floor; floral motifs have become flowers. Other patterns have taken on new meanings: geometric shapes form a flower, pieces of a world map have become a woman's body. These are Picasso's "mental illusions".

• Picasso did not imitate reality. He incorporated it by using the real material of wallpaper. He hardly needed to paint, because the paper was patterned already.

Analysis

• The space has been flattened using figures in close up, a very low floor and "parquet' seen from above. But the diagonals, at bottom right and top left, give an impression of perspective.

• The mirror shows the world the wrong way round: reflected is a right-sided profile of a blue face, a cold colour. The reality is a left-sided profile of a red face, a warm colour for flesh.

• The three women in the picture come together in the one, different woman in the mirror.

• The two women at the sides have the same profile. They look more like each other than the woman in the centre resembles her own reflection. "Objective" reality does not exist.

• The figures are seen from side and front at the same time. These different points of view give a more complete vision, showing movement.

Chronology

* work cited in text
• cultural life
 Cin. - cinema
 Lit. - literature
 Mus. - music
 Paint. - painting
■ historical event

MP Musée Picasso

1881
25 October, Pablo Ruiz Picasso born in Malaga (Spain), first child of Don José Ruiz Blasco (1938-1913) and Doña Maria Picasso y Lopez (1855-1939).
• Paint. - Manet, *The Bar of the Folies-Bergères*.
■ Jules Ferry introduces free, compulsory schooling in France.

1888
Starts painting under his father's supervision.

1894
His father, a drawing teacher, is so impressed by his son's talent that he gives up painting and donates his palette to his son.

1895
The family moves to Barcelona. Enters the Academy of Fine Art, La Lonja, where his father teaches.
* *Girl with Bare Feet* (MP)
• Paint. - Van Dongen, *Self-portrait in Blue*.*

1899
Returns to Barcelona. Frequents the cabaret *El Quatre Gats*. Becomes friends with the painters Nonell, Sunyer, Casagemas and Junyer-Vidal, the sculptor Mateo F. de Soto and the poet Sabartès.

1900
Shares a studio in Barcelona with Casagemas.
Exhibition of about 150 drawings at *El Quatre Gats*.
October - trip to Paris with Casagemas.
Studio in Montmartre.
1st art dealer, Mañach, offers him 150 F a month in exchange for pictures.
Berthe Weill buys three pastels.
December - returns to Barcelona with Casagemas.
Stay in Malaga.
• Paint. - Cézanne, *Apples and Oranges** (Musée d'Orsay).

Monet exhibits his *Nymphéas*.
Sigmund Freud - *The Interpretation of Dreams*.
Universal Exhibition in Paris.

1901
February - Suicide of Casagemas.
May - Second trip to Paris. Meets Max Jacob.
Studio at 130 Bd de Clichy.
Start of the "blue period".
1st Paris exhibition at Vollard's gallery (sells 15 pictures before varnishing).
Signs with his mother's name "Picasso" for the first time.
* *Self-portrait* (MP)
* *Death of Casagemas* (MP)
• Deaths of Toulouse-Lautrec and Verdi.
 Mus. - Maurice Ravel, *Jeux d'Eaux* in concert in Paris.
■ T. Roosevelt elected President.
■ Death of Queen Victoria.

1902
End of contract with Mañach.
April - Exhibition with Matisse and Marquet at Berthe Weill's gallery.
• Mus. - Debussy, *Pelléas et Mélisande*.
 Cin. - Georges Méliès makes *Journey to the Moon*.

1903
January - Returns to his parents in Barcelona.
* *La Vie* (Cleveland Museum)
• Deaths of Whistler, Gauguin and Pisarro.
■ Marie Curie receives Nobel Prize for Physics.

1904
Moves definitively to Paris, to the Bateau-Lavoir.
Relationship with Fernande Olivier (until 1911).

◄ 1900: Picasso, the sculptor Mateo F. de Soto and the painter Casagemas on the terrace at 3 Calle de Madrid, Barcelona. Photograph.

Frequents cabaret Le Lapin Agile
and the Medrano Circus.
Themes of circus and saltimbanques
appear.
End of "blue period".
• Paint. - Cézanne: Autumn Salon,
Montagne Ste Victoire.
Matisse, *Luxe, Calme et Volupté*.

1905
Meets Apollinaire and Leo and
Gertrude Stein.
"Rose period" begins.
First sculptures.
* *Family of Saltimbanques* (drawing)
(MP).
* *The Jester* (bronze sculpture) (MP).
• Paint. - Cézanne, *The Large Bathers*.
The Fauves at the Autumn Salon.
Mus. - Debussy, *La Mer*.
■ Separation of Church and State
in France.
■ Albert Einstein: Paper on Relativity.

1906
Meets Matisse and Derain.
Vollard buys most of the "rose"
pictures.
Trip to Barcelona with Fernande
(to his parents).
Stays in Gosol (Spain).
Influence of Iberian art.
* *Rose self-portrait* (MP).
* *The Two Brothers* (MP).
• Paint. - Cézanne dies.
Mus. - Maurice Ravel, *Spanish
Rhapsody*.

1907
Meets Braque and Kahnweiler.
Prepares *Les Demoiselles d'Avignon*
(finished in July).
Visits Musée d'Art Africain et
Océanien. Stunned by African art.
Visits Cézanne retrospective.
"Cézannian Cubism" begins.
Kahnweiler becomes his dealer.
* *Mother and Child* (MP).
• Paint. - Douanier Rousseau,
The Snake Charmer.
■ Lumière brothers take first colour
photographs.

1908
Begins Cubist researches with
Braque.
November - Great banquet in honour
of Douanier Rousseau in Picasso's
studio.
• Paint. - Marie Laurencin, *Apollinaire
and his Friends*.
Lit. - Guillaume Apollinaire,
L'Enchanteur Pourrissant ("The
Putrefying Spellbinder").
Mus. - Stravinsky, *Feu d'Artifice*.

1909
"Analytical" Cubism begins.
Trip to Barcelona and Horta de Ebro
with Fernande.
September - Moves to 11 Bd de
Clichy (on Place Pigalle).
First exhibition in Munich,
Thannhauser Gallery.
* *Head of Fernande* (sculpture) (MP).
• Paint. - Renoir, *The Clowns*.
Pierre Mondrian, *The Red Tree*.
Birth of Futurism with Marinetti.
■ Louis Blériot flies across the
Channel.
■ Riots in Barcelona.

1910
Stays in Cadaquès with Fernande,
Derain and his wife.
• Paint. - Kandinsky, *On the Spiritual
in Art*.
Douanier Rousseau dies.

1911
First exhibition in New York.
Summer in Céret (Pyrenees)
with Fernande and Braque.
Introduces numbers and letters
into his compositions.
Split with Fernande.
Start of relationship with Eva
Gouel (Marcelle Humbert).
• Lit. - Apollinaire, *Bestiaire*
("Bestiary").
Paint. - Modigliani, *Head in Profile*
(sculpture).*
■ Chinese revolution.

1912
First sheet-metal construction.
Start of "synthetic Cubism".

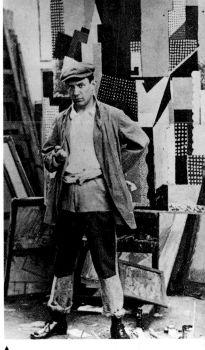

▲
Picasso in front of *Man leaning
on a Table*, 5 bis, Rue Schoelcher, Paris.
Photograph.

In Céret with Eva, Sorgues and
Avignon.
First pasted-paper works.
September - Moves to 242 Bd Raspail
in Montparnasse.
Signs 3-year contract with
Kahnweiler.
* *Still-life with Chair Caning* First
collage (MP).
* *Drawing of Renoir from a Photograph*
(MP).
Matisse, *Basket of Oranges* (MP)*
De Chirico, *Melancholy of a Street*
(MP).
• Mus. - Claude Debussy, *Prelude
to L'Après-midi d'un faune*.
■ Balkans War.
■ Titanic sinks.

111

◀ Picasso and Olga in London, where the drop curtain for *The Three-Cornered Hat* was made, 1919. Photograph.

Designs for *The Three-Cornered Hat*.
Summer with Olga at Saint-Raphael.
* *Still -life with Jug and Apples* (MP).
* *Still-life by a Window (Table and Guitar)* (MP).
• German art movement Bauhaus established.
Renoir dies.
■ Treaty of Versailles.
■ Weimar Republic.

1920
Designs for the ballet *Pulcinella* by Stravinsky.
Kahnweiler returns from exile.
* *Olga in a Feathered Hat* (drawing) (MP).
* *Study of Hands* (drawing) (MP).
• Paint. - Modigliani dies.

1921
4 February - Birth of Paulo, son of Picasso and Olga.
Collections of dealers Uhde and Kahnweiler seized and auctioned.
Summer in Fontainebleau with Olga.
Designs for *Quadro Flamenco* - Russian ballet.
Ballet Jean Cocteau, *Les Mariés de la Tour Eiffel*.

1922
The collector Jacques Doucet buys *Les Demoiselles d'Avignon* for 25,000 francs.
* Summer in Dinard. Paints *The Race*.
Drop curtain for *Antigone*.
• Lit. - James Joyce, *Ulysses*.
Cin. - Fritz Lang, *Doctor Mabuse*.
Murnau, *Nosferatu*.

1923
Several Harlequins in the "neo-classical" style.
Summer in Cap d'Antibes.
* *Pan's Pipes* (MP)

1913
Moves with Eva to 5 Rue Schoelcher.
• Lit. - Proust, *À la recherche du temps perdu* ("In Remembrance of Things Past").
Paint. - G. Braque, *The Guitar, Statue of Fear*.*
Mus. - Scandal of Stravinsky's *Rite of Spring*.
■ Second Balkans War.

1914
June - Avignon.
* *The Painter and his Model* (MP).
• Paint. - Léger, *The Stairs*.
■ First World War.

1915
December - Eva dies.
Meets Jean Cocteau.
• Malevich, *Suprematist Manifesto* (metaphysical painting).

1916
Meets Diaghilev, Director of the Russian Ballet, and the composer Satie.
Design for the ballet *Parade*.
Moves to Montrouge, 22 Rue Victor Hugo.
• Birth of the Dada movement in Zurich.
Lit. - Max Jacob, *Le cornet à dés* ("The Dice Cup").
■ Battle of Verdun.

1917
With Cocteau in Rome to work on *Parade*.
Meets Stravinsky and Olga Kokhlova.
Visits Pompeii and Naples.
Trip to Barcelona and Madrid with Olga.
Picasso's father dies.
* Costumes for *Parade* (design) (MP).
Illustration for *Le cornet à dés* ("The Dice Cup') by Max Jacob (MP).
Self -portrait (1917-1919) (MP).
• Sculptor Rodin dies.
■ The USA enters the war.
October revolution in Russia.

1918
Marriage to Olga at Russian Church of Paris.
His friend Apollinaire dies.
Kahnweiler in exile.
Moves to 23 Rue la Boétie, where he occupies two floors.
• Paint. - Malevich, *White Square on a White Background*.
■ 11 November: armistice.
Tsar and family executed.

1919
Meets Miró and buys a painting from him.
Spends three months with the Russian Ballet in London.

- Lit. - Yeats, Nobel Prize.
 Charleston invented.
 Cin. - Greta Garbo's debut.
- Hitler's failed putsch.

1924
Large still-lifes.
20 June - Premiere in Paris of
Diaghilev's ballet *Le Train bleu* with
a drop curtain by Picasso.
Takes part in the first Surrealist
exhibition in November.
* *Paulo as Harlequin* (MP).
- Lit. - André Breton, *Manifeste du
 surréalisme (Surrealist Manifesto)*.
 Paint. - Georges Braque, *Naiad**,
 drop curtain design.
 Mus. - Gershwin composes *Rhapsody
 in Blue*.

1927
Meets Marie-Thérèse Walter, aged 17.
* *The Guitar* (MP).
- Paint. - Juan Gris dies.
 Cin. - "Birth" of Mickey Mouse.
 Abel Gance, *Napoleon*.
- Civil war in China.
 Charles Lindbergh flies across
 the Atlantic.

1929
Works on wire sculptures with the
sculptor Gonzalez.
Breakdown of relationship with Olga.
Summer in Dinard.
* *Woman in an Armchair* (MP).
* *Seated Woman* (sculpture) (MP).
- Museum of Modern Art (MOMA)
 opens in New York.
 Cin. - Buñuel and Salvador Dalí,
 Un Chien Andalou
- Black Thursday on Wall Street.

1930
Summer in Juan-les-Pins.
Buys the Château de Boisgeloup,
near Gisors.
* *Composition with a Glove* (MP).
- Lit. - André Malraux, *La voie royale*
 (The Royal Road).
 Cin. - Buñuel, *L'Age d'or*.
- 107 Nazi members of the Reichstag.
 Ghandi arrested.

1931
* *The Sculptor* (MP).
* *Large still-life with Table* (MP).

1932
First retrospective in Paris at
Georges Petit's gallery, showing
236 works.
Christian Zervos publishes the first
volume of his *Catalogue*.
- Paint. - Otto Dix, *War*.
 Lit. - Céline, *Voyage au bout de la
 nuit (Journey to the End of the Night)*.
 Cin. - First Venice Film Festival.
- Franklin D. Roosevelt elected
 President of the USA.
- Assassination of French President
 Paul Doumer in Paris.

1933
Theme of the sculptor's studio and
the Minotaur, for the Vollard Suite.
Summer in Cannes with Olga and
Paulo.
Publication of Fernande Olivier's
*Mémoires intimes (Personal
Memories)*.
* *The Sculptor's Studio* (etching) (MP).
* *The Bullfight* (MP).
 Paint. - Matisse, *The Dance*.
 First issue of the Surrealist magazine
 The Minotaur (cover by Picasso).
 Hitler closes the Bauhaus.
- Lit. - Malraux, *La condition humaine*
 (The Human Condition).
 Federico García Lorca, *Blood
 Wedding*.
- Hitler becomes Chancellor of the
 Reich.
 First anti-Semitic measures.
 The Joliot-Curies invent artificial
 radioactivity.

1935
May to February 36 – Picasso stops
painting.
Etching cycle "Minotauromachia".
Separates from Olga. Division of
property.
5 October. Birth of Maïa Concepción.
Sabartès returns from South
America and becomes Picasso's
secretary.
Meets Dora Maar.

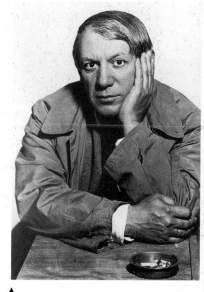

▲
Photograph of Picasso by Man Ray
(1932).

* Illuminated poetry "Sur le dos de
 l'immense..." ("On the back of
 immensity...") (MP)
- Paint. - Malevich dies.
 Hitler attacks modern art at Nuremberg.
 First Penguin book published in
 London.
 Mus. - Gershwin, *Porgy and Bess*.
- Italian troops invade Ethiopia.
 Nobel Prize for Chemistry awarded
 to Irène and Fréderic Joliot-Curie.

1936
Travelling exhibition of Picasso's
paintings in Spain (Barcelona, Bilbao
and Madrid).
Secret trip to Juan-les-Pins with
Marie-Thérèse and Maïa.
Picasso declares himself against
Franco.
Elected Director of the Prado by
the Republicans.
Autumn - Gives Boisgeloup to Olga.
Lives at Vollard's house.
* *Minotaur and Dead Mare...* (MP).

* *The Minotaur's Corpse Dressed in a Harlequin Costume* (MP).
• Paint. - André Masson, *Jet of Blood*. Dalí, *Premonition of Civil War*. Lit. - Céline, *Death on the Installment Plan*.

▲
Brassaï, Chair with newspapers, painting by Picasso and slippers, 1943. Photograph.
Picasso said to Brassaï, "It won't be a documentary photo... You moved my slippers. I never put them like that".

Federico García Lorca shot by Franco's supporters.
Mus. - Carl Orff composes *Carmina Burana*.
■ 18 July, Civil War starts in Spain. Berlin Olympics. Popular Front in France.

1937
Rents a new studio at 7 Rue des Grands-Augustins.
* 26 April. *Guernica* (Prado Museum). Painted for the Spanish Pavilion at the Universal Exhibition in Paris.

Visits Paul Klee in Berne.
Sells *Les Demoiselles d'Avignon* to the Museum of Modern Art in New York (for $24,000).
Holiday in Mougins with Paul and Nusch Eluard.
* *Weeping Woman* (MP).
* *Portrait of Marie-Thérèse* (MP).
* *Portrait of Dora Maar* (MP).
Universal Exhibition:
• Paint. - Dufy, *La Fée électricité*. "Degenerate" artists persecuted in Germany.
Lit. - Malraux, *L'espoir (Hope)*.
Mus. - Death of Maurice Ravel.
Cin. - Jean Renoir, *La Grande Illusion*.

1938
Summer in Mougins with Dora Maar.
Winter - Picasso suffers from sciatica in Paris.
* *Maïa with a Doll* (MP).
* *Women at their Toilette* (MP).
* *Self-portrait in Charcoal* (MP).
• Paint. - Surrealist exhibition.
Lit. - Jean-Paul Sartre, *La nausée (Nausea)*.
Mus. - First jazz concert at Carnegie Hall (New York).
Cin. - Marcel Carné, *Hôtel du Nord*.
■ Germany annexes Austria and the Sudetenland.
Otto Hahn splits the uranium atom.

1939
Picasso's mother dies.
Vollard dies.
July in Antibes with Dora and Sabartès.
War declared: joins Marie-Thérèse and Maïa in Royan.
Major retrospective in New York: 344 works shown, including *Guernica*.
* *Cat Catching a Bird* (MP).
• Paint. - Sale of "degenerate" art in Lucerne.
Lit. - John Steinbeck, *The Grapes of Wrath*.
James Joyce, *Finnegan's Wake*.
Cin. - Jean Renoir, *La Règle du jeu*.
■ Russo-German pact.
War declared between the Allies and Nazi Germany.
German troops invade Poland.
Spanish Civil War ends.

1940
In Royan until the summer.
August - Returns to Paris.
Leaves Rue de la Boétie and moves into his studio at Rue des Grands-Augustins.
• Paint. - Matisse, *The Romanian Blouse*.*
Paul Klee dies.
Mondrian and Léger in New York.
Lit. - Ernest Hemingway, *For Whom the Bell Tolls*.
Cin. - Charlie Chaplin, *The Great Dictator*.
■ Franco-German armistice.
Pétain becomes French Head of State.
18 June - Charles de Gaulle calls on the French to resist.
Roosevelt re-elected.

1941
Writes *Desire Caught by the Tail*.
Moves Marie-Thérèse and Maïa into Boulevard Henri-IV.
Cannot leave Paris to make sculptures in Boisgeloup, so sculpts in the bathroom instead.
• Paint. - Robert Delaunay dies.
Cin. - John Huston, *The Maltese Falcon*.
Orson Welles, *Citizen Kane*.
■ Germany attacks the USSR.
Japan attacks Pearl Harbour.
The USA enters the war.
First raid on Germany by the RAF.

1943
Meets Françoise Gilot.
Starts to paint again. Continues making assemblages.
* *Bull's Head* (sculpture) (MP).
* *Child with Doves* (MP).
• Paint. - First exhibition by Jackson Pollock in New York.
Soutine, "the Jewish painter", dies.
Lit. - Jean-Paul Sartre, *L'être et le néant (Being and Nothingness)*.
Saint-Exupéry, *The Little Prince*.
Paul Claudel, *The Satin Shoe* at the Comédie-Française.
Cin. - Henri-Georges Clouzot, *The Crow*.
■ Germans surrender at Stalingrad.
Allies land in Sicily.
Warsaw ghetto uprising.

1944

Max Jacob sent to concentration camp.
Reading of *Desire Caught by the Tail* with Sartre, Beauvoir, Camus, Queneau.
Picasso joins the Communist Party.
Exhibits at the Autumn Salon for the first time with 74 paintings (scandal).
* *Man with Sheep*, bronze sculpture (MP).
• Deaths of Kandinsky, Munch, Maillol, Max Jacob, Saint-Exupéry.
Paint. - Dubuffet/Vasarely exhibition.
Lit. - Sartre, *Huis clos (In Camera)*.
■ Paris liberated.
Germans routed in Russia.

1945

Begins lithography at the Moulot studio (200 works in four years).
July in Antibes with Dora.
Buys a villa at Ménerbes.
Paints *The Charnel House*.
* *Still-life, Pitcher and Skeleton* (MP).
• Paint. - Mondrian retrospective at MOMA.
■ Germany surrenders.
Atomic bomb dropped on Hiroshima and Nagasaki.
Conferences of Yalta and Potsdam.

1946

Visits his friend Matisse in Nice with Françoise.
Françoise moves in with Picasso at Rue des Grands-Augustins.
July in Ménerbes with Françoise.
Picasso works at the Musée d'Antibes: donates many pictures, including *The Joy of Life*.
First visit to Vallauris.
* *Portrait of Françoise* (in pencil) (MP).
• Paint. - Jackson Pollock's first action painting.
Lit. - Lucio Fontana publishes *The White Manifesto*.
Jean-Paul Sartre, *L'Existentialisme est un humanisme (Existentialism is a Humanism)*.
■ Nuremberg trials.

1947

Donates ten pictures to the Musée d'Art Moderne in Paris.
Birth of Claude (15 May), son of Picasso and Françoise.
Summer: starts working with ceramics at Madoura workshop.
Stays with the Ramiés in Vallauris (1947-1948 makes 2000 ceramics).
• Paint. - Musée National d'Art Moderne opens in Paris.
Bonnard dies.
Lit. - André Gide receives Nobel Prize.
Albert Camus, *La peste (The Plague)*.
Cin. - Charlie Chaplin, *Monsieur Verdoux*.
Henri-Georges Clouzot, *Quai des Orfèvres*.
■ *Exodus* affair.
The USSR breaks with the West.
Indian independence.

1948

Summer - Moves to villa "La Galloise" in Vallauris with Françoise.
Takes part in Bratislava Peace Conference.
Visits Crakow and Auschwitz.
Exhibition of ceramics in Paris.
* *Plate with Bunch of Grapes and Scissors* (MP).
* *Woman Vase* (ceramic) (MP).
* Illustrates *The Song of the Dead* by Pierre Reverdy.
Paint. - Birth of Cobra movement.
Rouault burns 315 paintings.
• Mus. - First international jazz festival in Antibes.
Cin. - McCarthy witch-hunt and blacklist.
Orson Welles, *The Lady from Shanghai*.
■ Communists seize power in Czechoslovakia.
Ghandi assassinated.
Berlin blockade.
Marshall Plan.
State of Israel declared.
"Cold War" begins.

1949

Lithograph *The Dove* used as logo for Paris Peace Conference.
Paloma born (19 April).
Rents an old perfume factory (Rue des Fournas) in Vallauris and sets up his studio there.

Starts sculpting again.
• Lit. - Simone de Beauvoir writes *Le deuxième sexe (The Second Sex)*.
George Orwell, *1984*.
Cin. - Jean Cocteau, *Orphée*.
Mus. - Richard Strauss dies.
■ People's Republic of China.
Creation of German Federal Republic.

▲
Picasso making the plaster sculpture *Woman with a Pram* in Vallauris, 1950. Photograph.

1950

Awarded Lenin Prize for Peace.
Elected citizen of honour at Vallauris.
Makes his own film at Vallauris.
* *The Goat* (sculpture) (MP).
* *The Goat* (painting) (MP).
* *Woman with a Pram* (brush sculpture) (MP).
■ Korean War.
Sino-soviet pact.

1951

Retrospective in Tokyo.
Paints *Massacre in Korea* (MP) to protest against "the American invasion".

Georges Picault, Picasso with Paloma at La Colombe d'Or in Saint-Paul-de-Vence, 1951. Photograph.

Gives up apartment in Rue la Boétie.
Ceramics in Vallauris.
* *Goat Skull, Bottle and Candle* (MP).
• Cin. - Alfred Hitchcock, *Strangers on a Train*

1952
* *Baboon with Young* (sculpture) (MP).
* *The Shadow* (MP).

1954
Meets Jacqueline Roque in Vallauris.
Splits up with Françoise.
With Maïa and Paulo in Perpignan.
* *Claude drawing Françoise and Paloma* (MP).
* *Portrait of Jacqueline with Folded Hands* (MP).
• Paint. - Deaths of Matisse and Derain.
Jasper Johns paints *The American Flag*.
■ French defeated in Vietnam at Dien Bien Phu.
Geneva Accords.
Polio vaccine developed at Pasteur Institute.

1955
Olga dies in Cannes.
With Jacqueline in Provence.
Major retrospective in Paris, then Munich, Cologne and Hamburg.
Clouzot makes *The Picasso Mystery*.
Buys villa "La Californie" in Cannes.
* *Bacchanal*, drawing (MP).
• Paint. - First Documenta.
Vasarely, *The Yellow Manifesto*.
Clement Greenberg defines the painting of the "colour field"
Rauschenberg, *The Bed*.
Tanguy dies.
■ Albert Einstein dies.
Warsaw Pact signed.

1956
Writes a letter of protest against the Soviet invasion of Hungary.
Deaths of Jackson Pollock and Berthold Brecht.
Albert Camus, *The Fall*.

1957
Exhibitions in New York, Chicago and Philadelphia.
58 variations on *Las Meniñas* after Velázquez.
Commissioned to paint a mural for the UNESCO building in Paris.
Brancusi dies.
Toreador Dominguez dies.

• Mus. - Pierre Boulez, *Third Piano Sonata*.
Cin. - David Lean, *Bridge Over the River Kwai*.
■ Treaty of Rome creates Common Market.
USSR: Kruschev is sole leader.
First Russian Sputnik lands on the moon.

1958
Buys Château de Vauvenargues near Aix-en-Provence (works there 1959-1961).
Finishes *The Fall of Icarus* for UNESCO.
UNESCO building opened, decorated with works by Picasso, Calder, Miró.
• Lit. - Marguerite Duras, *Moderato Cantabile*.
Mus. - *Artic Meet*, ballet by Merce Cunningham, to music by John Cage, set by Rauschenberg.
■ 13 May. Collapse of French 4th Republic.
De Gaulle returns.

1959
Starts working on variations on Manet's *Le Déjeuner sur l'herbe*.
Chapel of Vallauris opened.
Guggenheim Museum opens in New York.

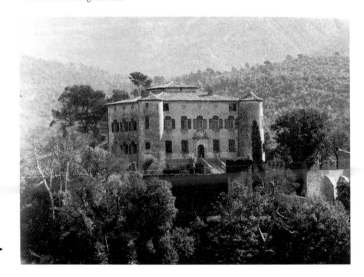

Edward Quinn, the Château de Vauvenargues, 1960. Photograph. ▶

International exhibition of Surrealism, "Eros", in Paris.
- Lit. - André Breton, *Constellations*.
Jean Genet, *Les Nègres (The Blacks)*.
Cin. - Alain Resnais, *Hiroshima mon amour*.
François Truffaut, *The 400 Blows*.
- Fidel Castro takes power in Cuba.

1961
Marries Jacqueline Roque in Vallauris: they move into Notre-Dame-de-Vie in Mougins, near Cannes.
Celebrates his eighty-fifth birthday at Vallauris.
* *The Footballer* (painted sheet-metal sculpture) (MP).
Paint. - Exhibition *The Art of Assemblage* at MOMA, New York.
- Lit. - Ernest Hemingway commits suicide.
Cin. - Alain Resnais, *Last Year in Marienbad*.
François Truffaut, *Jules et Jim*.
- Berlin Wall built.
Generals' putsch fails in Algiers.
Yuri Gagarin, first man in space.

1963
Picasso Museum opens in Barcelona.
Returns to the theme of "the painter and his model".
- Paint. - Deaths of Braque and Jean Cocteau.
Francis Bacon retrospective in USA.
Birth of the new figuration.
Lit. - Samuel Beckett, *Oh! les beaux jours (Happy Days)*.
Cin. - Jean-Luc Godard, *Le Mépris (Contempt)*.
Fellini, *8 1/2*.
- John Fitzgerald Kennedy assassinated in Dallas.
First Kodak Instamatic.

1964
Breaks with Claude and Paloma following the publication of *Living with Picasso* by Françoise Gilot.

Design for an immense metal sculpture for the Chicago Civic Center: *Woman's Head* (erected in 1969).
- Paint. - Robert Rauschenberg awarded the Grand Prize of the Vienna Biennale.
Opening of the Maeght Foundation at Saint-Paul-de-Vence.
Lit. - Sartre turns down the Nobel Prize.
Mus. - The Beatles triumph.
- Martin Luther King receives Nobel Prize for Peace.
USSR, Kruschev falls.

1966
"Homage to Picasso" - major retrospective in Paris (more than 700 works).
- Paint. - Alberto Giacometti dies.
Many "happenings" throughout USA and Europe.
Lit. - Foucault, *Les mots et les choses (The Order of Things)*.
- Cultural Revolution in China.
USA begins bombing of Hanoi.
Flood disaster in Florence.

1968
Sabartès dies.
In seven months, Picasso makes 347 etchings after *Las Meniñas*.
Donates 58 pictures to the Barcelona museum.
* *Painter and Child* (MP).
- Paint. - Marcel Duchamp dies.
Exhibition, "Art and the Machine" at the MOMA, New York.
Lit. - Marguerite Yourcenar, *L'œuvre au noir (The Work in Black)*.
Cin. - Stanley Kubrick, *2001, A Space Odyssey*.
- "Prague Spring".
May events in Paris.
Martin Luther King and Robert Kennedy assassinated.

1970
Picasso's family in Spain donate all the works in their possession to the Barcelona museum.

▲
Edward Quinn, Picasso and Jacqueline in the living room at "La Californie" around 1970. Photograph.

- Paint. - Deaths of Rothko and Barnett Newman.

1973
8 April, Pablo Picasso dies in Notre-Dame-de-Vie at Mougins aged ninety-two.
10 April, buried in the garden of his chateau at Vauvenargues.
- Lit. - Ionesco, *Le Solitaire (The Solitary Man)*.
- General Pinochet leads coup d'état against President Allende in Chile.
Watergate scandal in the USA.
Ceasefire in Vietnam.

Picasso and his friends

Portrait of Sergei Diaghilev, 1917. Rome. Gouache: 8.4 x 6.6 cm

Sergei Diaghilev

"Please draw attention our august protector the King that have just performed Spanish creation in collaboration two great Andalusian artists. Composer Falla and painter Picasso. Superb work, triumph with public and press in London. Am happy to inform His Majesty this news once again glorifying magnificent Spanish art."

(Telegram sent by Sergei Diaghilev to M. Torres, Secretary to the King, after the performance of *The Three-Cornered Hat* in London in 1919. B.N., Opera, fonds Kochno, item 32(5)) (Taken from the catalogue: *Diaghilev et les Ballets russes*, BN 1979).

Georges Braque

"At that time [of Cubism] I was very close to Picasso. Despite our different temperaments, we were both guided by the same idea [...].
During those years Picasso and I said things to each other that people will never say again... things that no one could understand now and which gave us so much joy, and all that will end with us."

Dora Vallier, *Braque, painting and us.*

Maurice de Vlaminck

"I was present at the birth of Cubism, its growth and its decline.
Picasso was the obstetrician, Guillaume Apollinaire the midwife, Princet its godfather and Derain, Max Jacob, Braque, Juan Gris, Salmon and I the assistants.
In other words I know Picasso... like my own pocket! [...]
Pablo Picasso is guilty of having taken French painting up the most fatal blind alley, into indescribable confusion. From 1900 to 1930 he led it into negation, a dead end, death."

"Free opinions... on painting" in *Commædia du samedi*, June 1942.

Henri Matisse

"Picasso was furious that I was doing a church – 'Why don't you do a market? You could paint fruit on it, vegetables'.
But I couldn't care less; I've got greens greener than pears and oranges more orange than pumpkins. So what's the point? He was furious."

(9 August 1945).

"I don't know what to think about it, but in any case there's only one person who's got the right to criticise me and that's Picasso."

Matisse on his paintings for the Vence chapel, Hélène Parmelin, *Picasso says.*

Portrait of Guillaume Apollinaire, summer 1918, Biarritz. Pen and violet ink: 13.5 x 8.7 cm.

Caricature of Jean Cocteau, 1917, Rome. Gouache: 19.5 x 6.8 cm.

Guillaume Apollinaire

"We hear from Montrouge
That Monsieur Picasso
Is making a painting that moves
just like this cradle
and long live the brush
of our friend Picasso." (1916)

"It is said of Picasso that his works reveal a premature disenchantment.
I think the opposite.
Everything enchants him and his incontestable talent seems to me to serve an imagination that judiciously combines the delicious and the horrible, the abject and the delicate."

Louis Aragon

"[...] Oh painter oh father of later oh overstepper of all
 [bounds

Hail to you who are on earth and not in the imagined
 [heavens

Hail to you Pablo by whom we are

yesterday's steps towards forever

To you Pablo, whom I here name for all time Young man."

Extract from the "Speech for the great days of a young man called Pablo Picasso", 27 October 1971.

Jean Cocteau

"[...] At my house, under an upturned glass, I have a cardboard dice, which he cut out, folded and coloured. I use it as an experiment. For anyone who scorns this little thing and claims to like Picasso does not like him for the right reasons."

Between Picasso and Radiguet, 1923.

"I find it hard to bear the golden weight of museums,
The immense vessel
I hear so much more clearly than their worn mouths
 The work of Picasso

There I saw the objects that float in our bedrooms
too large or too small,
At last the way love mingles mouths and limbs,
 profoundly built!

The muses have caught this painter in their dance,
 and guided his hand,
So that, on the adorable disorder of this world,
 he can impose human order.'

(1919)

Jean Arp

"Picasso is as important as Adam and Eve, as a star, a spring, a tree, a rock, a fairy story, and will stay as young, as old as Adam and Eve, as a star, a spring, a tree, a rock, a fairy story."

Answer to a survey in *Jardin des arts* n°. 112, March 1964.

*Portrait of
André Derain*,
1917, London.
Lead pencil:
39.9 x 30.8 cm.

*Portrait of
André Breton*,
Frontispiece
for *Earthlight*,
1923.
Dry point:
15 x 10 cm.

André Derain

"He would say of him, 'He has line and no brush. He's a graphic artist... A brilliant graphic artist, like Jacques Callot... He should stick to that... He sometimes spreads paint over his graphics, but it takes more than that to be a painter.' And he would add, 'He's a museum historian.

Now we have the catalogue of the Museum of Mankind, what's the point of Picasso?'"

G. Hilaire, *Derain*.

René Char

"Picasso sometimes felt like a prisoner, but a prisoner without a jailer, of the perfect knowledge that brings sadness and melancholy into being. But never nostalgia."

21 May, 1973. Diary extract.

Jacques Prévert

"[...] and the Minotaur, calmed and reassured, finds a taste for life once more [...] he shakes up all the myths of mythology in one go and quietly sets off, straight ahead, on his back legs.
But Picasso is waiting for him at the corner with his burin, one day he will have to go the same way as the others, this Minotaur, and if it isn't today it will be tomorrow that he is put to death."

"Picasso's etchings", *Spectacles NRF*, Paris, 1951.

André Breton

"[...] I like it so much, when some pictures by Picasso are taking their place in the world's museums, that he makes room in the most generous way possible for all that should never become an object of admiration, commission or speculation other than the intellectual kind [...]"

"Picasso in his element", *The Minotaur* 1, 1933.

Paul Eluard

"A crowd of portraits
One is scorn the other conquest
Another clear, slapping water
Another a bell of dew
The most subtle is a phantom
It goes down to earth and flatters its fellows

Here are the portraits of a friend
Hiding the milk of her breast
Under dazzling cloth
Facing the dial of her face
A poor little sun trembles
Tender mirror

Mirror of all truth
Of all windows in the morning
For an ancient blue dance
At the edge of two innocent eyes
Sensitive portraits trusting
In good loving logic."

Extract from *To Pablo Picasso*, 1944.

Portrait of
Max Jacob,
1917,
Montrouge.
Lead pencil:
32.6 x 25.3 cm.

Portrait of
Pierre Reverdy,
Frontispiece
for *Hemp Tie,*
1922.
Etching:
11.8 x 88 cm.

Max Jacob

"I have not written anything about Picasso. He hates to be written about... Some friends have lived off his name by means of echoes, stories, fantasies. Well... later... we'll see... but much later and in fact I think never..."

Letter to Jacques Doucet in January 1917.

"To Picasso
For what I know that he knows
for what he knows that I know"

Dedication of the poem *Saint Materel*, 1910.

Michel Leiris

"No, Picasso did not get devoured by things. You know, he too was *the bull and the bullfighter, and he would come away from these conflicts covered in banderillas.* He did not get devoured, because the bull defends himself, he is blind; that's why he is frightened, but he attacks. And I think that if Picasso attached such importance to the theme of the "Minotaur", it was because he was both matador and bull."

Picasso: Celebration of the Centenary of a Birth 1881-1981.

Pierre Reverdy

"My dear Picasso
this is nothing
not a letter, not a poem
a few words
fervently written
for you.
For our friendship
and my admiration
that the great artist that you are deserves."

Letter sent to Picasso in 1922, accompanying a poem.

Blaise Cendrars

"[...] He is above all the painter of the real. Human beings, animals, plants, misunderstood matter, spindly abstraction, everything lives, grows, suffers, mates, multiplies, disappears, moves, grows again, threatens, imposes itself, crystallises. He is the only man in the world who knows how to paint heat, cold, hunger, thirst, perfume, smell, tiredness, annoyance, desire, paralysis, palpitation, tugging, the obscure jerking of the 'enormous and delicate' subconscious [...]"

Extract from *Today,* Paris, 29 May 1919.

Glossary

Action painting

The term for a type of work, originating in America, that emphasises the physical, gestural act of painting. Its first representative was the American painter Jackson Pollock, who adopted the technique of "dripping" paint in 1947.

Aquatint

An engraving process related to etching and intended to give effects of flat tinting similar to those obtained by a wash in drawing.

Brush stroke

The method by which the colour is applied.

Burin

The name of an engraving tool and of the technique associated with its use. It allows for clear, strong lines, delicate shading and varied tones.

Canvas

Cloth made from linen, cotton or hemp fibres, used as a support.

Ceramic

Term derived from the Greek *keramon* (clay) – earthenware, china or porcelain pottery.

Charcoal

Burnt wood. Usually used for making preliminary sketches.

Chiaroscuro

The use of diffuse light on a dark background, bringing out contrasts of dark and light.

Classicism

Term derived from the Latin *classicus* (first class) – the balanced, constructed form used by artists who find their sources of inspiration in Greco-Roman Antiquity. In Picasso's work the "classical" or "neo-classical" period refers to the years 1917-1924 (see *The Race* or *Le Train bleu*).

Collage

A technique by which fragments of different materials, particularly pieces of cut paper, are assembled and stuck to a background material. More precisely termed *papiers collés* or "pasted paper" (see *Still-life with Chair Caning*).

Colours

Primary – there are three of these, from which all others are derived: red, yellow and blue.
Secondary – the result of mixing two primary colours: green, violet and orange.
Complementary – each primary colour has a corresponding secondary colour that heightens it:
green is the complementary colour of red,
violet is the complementary colour of yellow,
orange is the complementary colour of blue.

Composition

The formal organisation of the scene painted or drawn; the lines of composition structure the picture.

Conté Crayon

At the time of the French Revolution, Conté (1755-1805) invented an artificial lead by mixing natural powdered graphite with clay.
This was then heated. A wide range of tones can be obtained by varying the amount of clay and period of heating. The modern crayon is derived from the Conté crayon.

Copy

The imitation or reproduction of a work of art; not to be confused with an "interpretation", which is the creation of an independent work, inspired by a work of art (practised notably by Picasso).

Dry point

An engraving technique in which a steel stylus is used to draw directly on a copper plate and the resulting "burr" is left in place. The name also applies to the tool and the print made by this process.

Easel

A wooden frame that supports a picture while it is being worked on.

Engraving

The art of creating images by cutting into any surface. The name given to the result obtained by printing from the engraved and inked material, usually on to paper.

Depending on the process used, engraving can be done on wood (wood engraving or woodcut), metal (burin, etching), stone (lithograph) or linoleum (linocut).

Etching

The process of engraving metal using an acid. The word is used for both the technique and the print itself (see *The Sculptor's Studio*).

Fauvism

An artistic movement that appeared in 1905 and owes its name to a critic's jibe (he likened the works to "wild beasts"). For a few years it included some of the main painters of the 20th century (such as Matisse, Derain, Vlaminck, Van Dongen, Braque and Dufy).

This style of painting was characterised by heightened colour (bearing no relation to the colour of the object represented), a rejection of perspective, space, light and Impressionist naturalism.

Flat colour

Uniformly applied colour, with no brush marks or shading.

Gouache

Water-based paint, and the work produced, in which pigment is bound with glue and made more opaque than watercolour by adding white so that colours can easily be superimposed.

Gum arabic

A gum obtained from the acacia plant, used to bind watercolour, gouache and pastel.

Lead pencil

Name usually applied to a graphite pencil, which makes a grey line with metallic flecks.

Lithography

Term derived from the Greek words *lithos* (stone), and *graphein* (to write). The technique of producing prints of designs drawn directly on limestone with a greasy chalk. The stone is wetted and the ink adheres to the chalk but not to the damp stone. Discovered in 1796 by Aloïs Senefelder (see *The Sculptor's Studio*).

Mythology

Term derived from the Greek words *mythos* (fable) and *logos* (knowledge) – the fantastical stories of ancient gods and heroes.

Oil paint

Paint made of pigment ground and bound together using easily drying oil, often linseed. Oil paint can be used on any material that has been prepared in advance.

Paint layer

The layer on a canvas between the preparation and the varnish. It usually includes the sketch, the first version, the intermediate layer of colour and the final version.

Painting out

The artist's alteration of a composition during its execution.

Palette

Word used for the round, oval or rectangular surface on which to mix paint, and for the range of tones or colours used by a painter.

Pastel

Material, often crayon-shaped, made from a mixture of powdered colour and ground gypsum, formed into a paste with glue or gum arabic. The term also refers to the picture made with pastel crayons.

Pigment

Substance from which a colour is made. Pigment can be organic, inorganic or chemical in origin and must be mixed with a liquid before being used in painting.

Print

An image, often on paper, made from the impression of an engraving or drawing on metal, wood, stone, lithographic plate, etc.

Pure colours

Colours applied to the canvas without prior mixing, straight from the tube or pot.

Relief painting

The imitation of three dimensions on a flat surface.

Repainting

Alteration of a composition by someone other than the original artist.

Rough sketch

A preparatory drawing, in pencil, pen or colour, that gives only the essential lines, preceding studies and sketches.

Scratching out

A painting technique that involves scratching or scraping the paint layer to reveal the canvas beneath. To obtain a different texture, scratching out can be done by placing the canvas on a rough surface; a technique often used by painters such as Max Ernst and Paul Klee.

Shade

The variety or degree of colour obtained by mixing several tones. The term also refers to various types of the same colour; for example a range of blues includes cobalt, indigo, Prussian Blue and ultramarine.

Sketch

The first stage of a work, indicating the overall subject and its main parts. A sketch may be drawn with pen or pencil, or painted on a canvas.

Stretcher

The wooden frame across which the canvas to be painted is stretched and fixed.

Study

A drawing or painting that precedes the final painting. Usually the painter studies some elements of the composition in greater detail (such as anatomy, groups or draperies).

Support

The solid material on which the picture is made. The most commonly used supports are canvas, paper and wood.

Surrealism

A literary and artistic movement whose aim was to free the psyche by excluding logic and all moral and aesthetic considerations (see *Woman in an Armchair*).

Thinning

A gradual lessening of a colour's brilliance. Thinning takes a colour through all the degrees of value.

Tone

The value or degree of intensity of a shade or colour, from darkest to lightest.

Underpainting

The application of a coat of thinned, uniform colour before the painting proper is begun.

Value

The degree of intensity of a tone in relation to light and shadow. It can also be described in terms of its degree of coldness or warmth.

Wash

Method of colouring a drawing using Indian ink or any other material thinned with water.

Watercolour

Water-based coloured paint in which pigments are bound with gum arabic. More transparent than gouache, watercolour is applied to a support of paper or card. The term also applies to the print itself.

Photographic credits

Copy-editor: Melissa Larner
Cover: Thierry Renard
Graphic Design: Maxence Scherf
Layout and composition: Jérome Faucheux
Photoengraving (text): Daïchi, Singapore
Photoengraving (cover): Offset Publicité, Paris
Printed by Arti Grafiche E.Gajani, Rozzano - Milan
September 2001
Copyright registered April 1999